IMAGES
of Rail

JOHNSTOWN TROLLEYS AND INCLINE

Best wishes to Richard
February 17, 2024
Kenneth C. Springirth

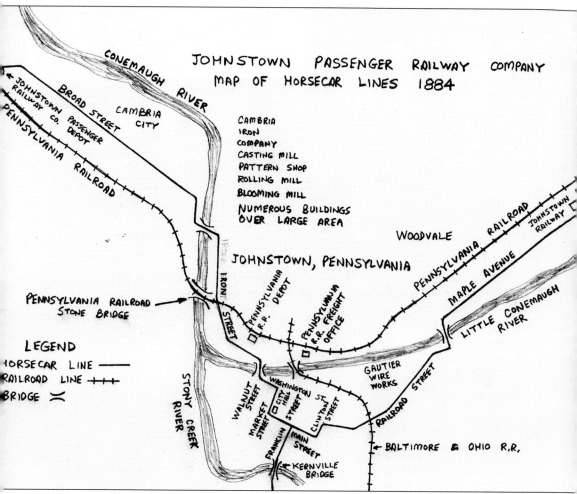

This 1884 map shows the Johnstown Passenger Railway Company horsecar lines. The April 10, 1883, *Johnstown Tribune* noted, "The first rail was laid on the 12th of September, 1882." There were six horsecars, 30 horses, and stables along with a blacksmith shop. The fare was 5¢, and a box was provided at each end of the car for the depositing of tickets.

On the cover: Johnstown Traction Company trolley No. 355 (1926 vintage St. Louis Car Company built city car), followed by trolley No. 311 (1922 Wason built double truck Birney safety car), pause for a photograph stop on the Maple Avenue bridge on the Franklin line on the last day of operation: June 11, 1960. (Kenneth C. Springirth photograph.)

IMAGES of Rail
JOHNSTOWN TROLLEYS AND INCLINE

Kenneth C. Springirth

Copyright © 2006 by Kenneth C. Springirth
ISBN 978-0-7384-4583-7

Published by Arcadia Publishing
Charleston, South Carolina

Printed in the United States of America

Library of Congress Catalog Card Number: 2006926358

For all general information contact Arcadia Publishing at:
Telephone 843-853-2070
Fax 843-853-0044
E-mail sales@arcadiapublishing.com
For customer service and orders:
Toll-Free 1-888-313-2665

Visit us on the Internet at www.arcadiapublishing.com

This book is dedicated to the author's grandson Angelo Timothy Ruggio, whose wide-eyed curiosity about the world around him encourages the author to keep on learning and discovering. Kenneth Springirth is seen here holding Angelo Timothy Ruggio by an O-gauge model of Johnstown Traction Company trolley car No. 362 on May 12, 2006. (Kathleen Ruggio photograph.)

CONTENTS

Acknowledgments		6
Introduction		7
1.	The Beginning Years	11
2.	System Growth	19
3.	Abandonment of Trolley Car Service	49
4.	Johnstown Incline	107
5.	Cambria County Transit Authority	121

Acknowledgments

Frank Julian Sprague (born July 25, 1857, died October 25, 1934) was the father of the trolley car. He formed the Sprague Electric Railway and Motor Company that completed a 12-mile electric trolley line in Richmond, Virginia, on February 2, 1888, with 10 trolleys in operation, which was the first practical system. Gear locking, commutator, and brush problems had to be corrected, and by May 4, 1888, the Richmond system had 30 cars in operation. Laboring under enormous difficulties, Sprague's vision and technical ability to bring together the best features of all the existing systems established the future growth of electric street railway systems, which grew in the United States from 1,200 miles in 1890 to 48,000 miles by 1917. Peter Perret, retired Cambria County reference librarian, was a constant source of information for this book. Joan Fritz, Cambria County periodicals librarian, was helpful with the microfilmed newspapers. Cambria County Library and staff were excellent in making information available. This is a user friendly library system. Rose Lucey-Noll, chief assistant to the general manager, and James E. Parks, urban operations and risk management of the Cambria County Transit Authority, provided information and pictures on the transit system and incline. Robin Rummel, archivist of the Johnstown Area Heritage Association, supplied information and pictures. Harold Jenkins, the first general manager of the Cambria County Transit Authority, provided information and pictures on Johnstown's public transportation history. Street Railway Journal, Electric Railway Journal, Electric Railroaders' Association Headlights, plus the microfilm files of the Johnstown Tribune and Johnstown Tribune-Democrat at the Cambria County Library were major sources of information. Johnstown Traction Company operated the last small city trolley car system in the United States, and many of its vintage trolley cars are in museums throughout the country. My father was a trolley car motorman in Philadelphia and, like his associates, served as a combination guide, host, salesman, and public relations professional during his outstanding years of guiding trolley cars through the labyrinth of city traffic. My mother was a practical resourceful person who would always have dinner ready to meet dad's work schedule. Lastly today's transit vehicle operators in Johnstown deserve recognition for providing accessibility to the riding public.

INTRODUCTION

The April 10, 1883, *Johnstown Tribune* reported that Johnstown Passenger Railway horsecar No. 6 made an eight mile round trip that morning from the railroad's stable to the railroad crossing at Morrellville in 1 hour and 25 minutes. The newspaper noted, "The first rail was laid on the 12 of September, 1882. There were many delays of various kinds which prevented completion of the road until the winter set in, and it was then deemed advisable to postpone the opening of the line until this spring." The three-and-a-half-mile main line connected the borough of Franklin through the city to the edge of Morrellville. There was a branch line that extended from Main Street south on Franklin Street to what is today Valley Pike. After the May 31, 1889, flood that wiped out the trolley system, Tom L. Johnson (of the Johnson Steel Works, later United States Steel Company) purchased the company, and it was rebuilt as an electric trolley line. The carbarn was built on Central Avenue in Moxham. On March 11, 1893, the carbarn at Moxham was destroyed by fire. A new carbarn was built at Central Avenue and Bond Street that is today the bus garage. In 1896, the lines to Roxbury and Franklin opened, followed by Dale in 1897. On November 4, 1898, the Johnstown Passenger Railway and Johnstown Somerset Traction merged, and the line was built to Jerome but never reached Somerset. Construction of the Windber line began in 1900. Windber was completed in 1901 along with the Horner Street line and service was extended south from Moxham to Ferndale.

On July 15, 1908, Windber streetcar No. 104 collided with a Baltimore and Ohio Railroad train where the tracks turn off Valley Pike (which is now Ferndale Avenue) in Ferndale to go across the Baltimore and Ohio track into Moxham. Under the headline "One Killed and Forty Injured in Windber Street Car Wreck" the *Johnstown Tribune* newspaper of July 16, 1908, noted, "The impact of the collision was so great that all the passengers numbering in the neighborhood of 100 were thrown to the front of the car." The car moved backwards at a terrific speed and the article continued, "Suddenly the lurching car hit the curve. There was a cracking of timbers, a terrible bump, a scraping along the ground and for a second all was still. The car was lying on its side over a slight embankment. The many passengers in the car were frantic by this time. The stronger trampled over the weaker and the confusion could not have been greater." Rescuers arrived promptly and within 30 minutes every one was out of the car. The article noted, "The people living in the immediate neighborhood were very considerate and threw open their homes for the comfort of the injured. They also supplied medicine, water, and whatever could be used for bandages."

Johnstown Passenger Railway Company was merged with the Johnstown Traction Company on February 13, 1910. The Oakhurst line opened in 1911. Saturday, December 30, 1911, a work car was

used in stringing wire for the Southmont line as reported by the Tuesday, January 2, 1912, *Johnstown Tribune* newspaper. Saturday, June 29, 1912, at 5:00 p.m. the first car left Main Street at city hall for Southmont. The July 1, 1912, *Johnstown Tribune* newspaper noted, "As the special wound its way along the picturesque route, people living along the right of way and golfers on the Country Club links waved a welcome in response to the shrill blasts of the whistle on the car." Before the Fairfield underpass was constructed, passengers for Morrellville had to take a car to Coopersdale, walk across the Pennsylvania Railroad tracks, and board a shuttle car for Morrellville.

Beginning Tuesday, January 23, 1912, the Southern Cambria Railway began service from Johnstown to Ebensburg, but passengers initially had to walk 12 blocks to reach downtown Ebensburg. The January 20, 1912, *Johnstown Tribune* newspaper in advance of the opening noted that trolleys would leave from Main and Franklin Streets in Johnstown at 7:45 a.m., 10:45 a.m., 1:45 p.m., 4:45 p.m., and 7:45 p.m. Trolleys would leave Ebensburg at 9:15 a.m., 12:15 p.m., 3:15 p.m., and 6:15 p.m. One car was used and the one-way fare was 50¢. According to the January 29, 1912, *Johnstown Tribune* newspaper, "Traffic over the Southern Cambria Railway was heavy yesterday, the first Sunday it has been posted on schedule." The May 30, 1912, *Johnstown Tribune* newspaper covered the opening of the Southern Cambria Railway with the special car, which left Johnstown at 5:45 p.m. and arrived in Ebensburg at 6:52 p.m. on May 29, 1912. Southern Cambria Railway president P. J. Little addressed the Johnstown delegates at a banquet at the Metropolitan Hotel declaring, "No more important work is today being accomplished in the field of transportation than the development of suburban trolley lines." He commented that street railway lines serve, "as arteries of distribution for county produce as well as distribution of groceries for city stores, and more particularly the carrying of the busy interurban dweller to his city office." The special car left Ebensburg for Johnstown at 11:20 p.m. and arrived at Main and Franklin Streets in Johnstown in one hour.

On May 2, 1912, two passengers were killed and 25 injured in a head-on collision on the Windber trolley line at Krings. The *Johnstown Tribune* newspaper of May 10, 1912, reported that Johnstown Traction Company superintendent Evan M. DuPont stated, "Both the motorman and conductor were told to go to Krings Station and call by telephone to the office to receive orders. Both admit they were told the orders, and both admit they forgot the orders."

Saturday, August 12, 1916, at 10:45 a.m., two Southern Cambria Railway trolleys collided head-on between the villages of Echo and Brookdale, killing 26 passengers as reported by the August 14, 1916, *Johnstown Tribune* newspaper, and 40 to 50 were injured. The car that left Johnstown at 10:00 a.m. was crowded with people going to the Dishong-Ribblett reunion at Woodland Park near Ebensburg and to a picnic of the Burkhart Sunday School. The *Johnstown Tribune* reported, "The impact of the cars was so great that both were telescoped probably six feet and most of those killed were in the forward part of the cars. Both cars remained on the track." Southern Cambria Railway made the following statement on the wreck: "The Ebensburg car was in charge of Conductor McDevitt and Motorman Varner, two experienced employees. The car was heard approaching the carbarn by employees in the office and it was evident that it was beyond control. Motorman Varner waved his arms and Superintendent Nichols immediately rushed to the power house to shut of the power. Before this could be done the cars met a short distance from the power house. Owing to the condition of Conductor McDevitt, who is badly injured, it is impossible to determine how the Motorman lost control of his car." The August 14, 1916, *Johnstown Tribune* commented that Mercy and Memorial Hospitals did magnificent work for the accident victims in handling "the work of relief with machine like precision."

The August 14, 1916, *Johnstown Tribune* newspaper reported that a Southern Cambria Railway car that left Johnstown at 5:00 p.m. was derailed by a steel nut at Riverview, about a mile from the scene of the August 12, 1916, accident. With the memory of the August 12, 1916, accident in their minds, many of the passengers walked back to Franklin fearing to continue their journey to the borough of Ebensburg.

On November 15, 1922, the Traction Bus Company was formed as a subsidiary company, and seven days later, bus service began from the Dale trolley loop to Scalp Level. Southern Cambria

Railway abandoned trolley service to Ebensburg on December 18, 1928. A reorganization committee purchased, at a Special Master's Sale held on November 26, 1932, all of the property of the Johnstown Traction Company. Due to the massive damage by the March 17, 1936, flood, the Windber line was cut back to Benscreek. The March 23, 1936, *Johnstown Tribune* noted that "the 32 cars caught in the flood were scattered all over the city" and continued, "Some of them were entirely engulfed by the onrushing tide of water." At the carbarn motors were disassembled and dried, bearings cleaned, and parts checked. Almost the whole way from the stone bridge to Coopersdale the overhead was down, but workers were busy restoring the overhead lines throughout the system. Approximately 200 Johnstown Traction Company employees, including motormen and office employees, were involved in the cleaning up and rehabilitation of the flood damaged system. The *Johnstown Tribune* newspaper of Friday evening, August 2, 1940, reported that "the last run on the Dale line was made shortly before 10 a.m." this morning.

Three hundred Johnstown Traction Company trolley car, bus, and maintenance personnel went on strike early morning Saturday April 24, 1943. According to the *Johnstown Tribune* newspaper of April 24, 1943, "The hours worked by these members was from 50 to 60 hours per week and were reduced to a maximum of 48 hours per week without an increase in pay as was asked for in the new contact." The strike lasted 18 hours and service was restored about 10:30 p.m. that day. The Monday evening, April 26, 1943, *Johnstown Tribune* newspaper noted, "Both the union and the company reported that the one day work stoppage was peaceful, and that no reports of violence were received." A three day transit strike, which had been called in protest to the Regional War Labor Board decision granting wage increases of 8¢ per hour less than had been awarded by an independent arbitration board, occurred 4:30 a.m. Sunday, June 13, 1943. The June 16, 1943, *Johnstown Tribune* newspaper reported, "The local strikers voted by a substantial majority to return to the buses and streetcars." Service was restored about 7:30 p.m. on June 15, 1943. Ridership grew during World War II with yearly figures as follows: 1942 a total of 19,130,285; 1943 a total of 23,266,162; 1944 a total of 23,656,094; 1945 a total of 23,909,447; 1946 a total of 23,693,380; and 1947 a total of 24,722,124 (first year of Presidents' Conference Committee car operation). Yearly ridership then declined as follows: 1948 a total of 23,543,538; 1949 a total of 19,672,987; 1950 a total of 14,908,685; 1951 a total of 16,063,394 (first year of trackless trolley operation); 1952 a total of 13,517,589; 1953 a total of 11,264,606; 1954 a total of 8,860,677; 1955 a total of 8,264,789; 1956 a total of 7,753,318; 1957 a total of 7,299,990; 1958 a total of 6,231,420; 1959 a total of 5,452,239 (steel mill strike); 1960 a total of 5,830,202 (rail service ended June 11, 1960, with bus service substituted until trackless trolley overhead was completed), 1961 a total of 4,830,972; and 1962 a total of 4,443,777.

On November 20, 1951, the Horner Street line was converted to trackless trolley operation. Ferndale and Coopersdale lines were converted to bus operation on November 25, 1959. All trolley car service ended on June 11, 1960, with cars returning to Moxham carbarn as follows: No. 414, No. 411 (last regular service car), No. 355 (first car of Pittsburgh Electric Railway club (PERC) fan trip, No. 311 (second car of PERC fan trip), No. 413 (private fan trip car), No. 352 (third car of PERC fan trip) No. 409 (first special car), and No. 412 (second special car, which was the last car to operate in Johnstown). The *Johnstown Tribune-Democrat* newspaper of January 22, 1965, noted that ridership was up slightly in 1964. In 1963, ridership was 4,334,241 of which 2,170,984 was trackless trolley and 2,163,257 was bus. The 1964 ridership was 4,385,552 of which 2,205,405 was trackless trolley and 2,180,147 was bus. This was the first increase since 1960. During July 1965, the Conemaugh line was converted from bus to trackless trolley operation. Under the headline "Traction Company to Spend $250,000 on Carriers" in the August 6, 1966, *Johnstown Tribune-Democrat* newspaper, Warren G. Reitz, Johnstown Traction Company president and general manager, outlined the purchase of new buses and noted that the trackless trolleys may be nearing the end of the line because of the extra cost of having two separate shop facilities. Saturday, November 11, 1967, was the last day of trackless trolley operation in Johnstown. The last regular coach was No. 741, built by Marmon Herrington leaving downtown for Conemaugh at 5:20 p.m. and leaving Conemaugh Loop at 5:40 p.m.

Construction of the Johnstown Incline began in 1890, and it was opened June 1, 1891. Samuel Diescher of Pittsburgh designed the incline. It is a balanced inclined plane having a double track with two cars permanently attached to steel cables, counterbalancing each other while in operation. As one car rises, the other car is lowered. During the March 17, 1936, flood, nearly 4,000 were hauled to Westmont as reported by the April 1, 1936, *Johnstown Tribune* newspaper, "In addition to rendering inestimable service, the incline plane has been given credit for cheering up many persons marooned in downtown office buildings the night of the flood. Persons, who were marooned, afterwards said it gave them a sense of security to see the lights of the incline cars moving up and down the hill." At midnight on January 31, 1962, the Borough of Westmont closed the incline, because it was subsidizing the operation by $20,000 per year. The *Johnstown Tribune-Democrat* newspaper of February 1, 1962, reported that 24 people rode the last trip with one of the comments being, "I don't think this really will be the last trip." Bethlehem Steel Company was removing a 25 cycle power line in a modernization program at its Johnstown plant, and it would cost $51,000 to change the power and install new equipment at the incline. It was leased to the Cambria County Tourist Council and reopened July 4, 1962.

With a decline in riding, Johnstown Traction Company wanted to get out of providing transit service. On December 1, 1976, Cambria County Transit Authority, formed by the county commissioners, leased Johnstown Traction Company assets and officially began providing transit service in the Johnstown area. On Friday, July 17, 1981, the Cambria County Transit Authority dedicated a new downtown Johnstown Transit Center as part of a $6 million Main Street East redevelopment project. The *Johnstown Tribune-Democrat* newspaper of Saturday, July 18, 1981, noted, "Area civic leaders touted completion of the sprawling transit center, parking garage, and commercial office complex as a giant step in the city's downtown renaissance." Trolley cars are featured in the mosaic tile of the transit center, and a renaissance trolley shuttle, using buses designed to look like trolleys, serves the downtown area. The Cambria County Transit Authority purchased the incline for $1 on April 12, 1982. A complete overhaul of the system was completed, and the incline was rededicated on September 6, 1984.

One

THE BEGINNING YEARS

The May 31, 1889, Johnstown flood virtually demolished the horsecar lines of the Johnstown Passenger Railway Company. The company reorganized and was headed by Tom L. Johnson, with Dr. B. L. Yeagley as secretary and J. B. Hoefgen as vice president and treasurer. The lines were rebuilt as electric trolley lines. Construction commenced on the route from Moxham to Morrellville, and the first section completed was from Moxham to central Johnstown. The *Johnstown Tribune* newspaper of November 10, 1890, stated, "Accordingly, a turntable was procured and located on Morris Street near the south end of the Franklin Street bridge, and on Saturday afternoon November 1st at 1 o'clock the cars began making trips at regular 15 minute intervals. The motive power however, was not the old bay mare and the frisky mule. It was electricity, that mysterious energy now in such common and varied use, and yet so imperfectly understood by scientists as well as the general public." The article noted that the powerhouse was on Bedford Street and inside dimensions were 60 feet by 40 feet. The powerhouse contained three Ball engines each rated 125 horsepower and each drove a Brush generator. Dynamos produced an electric current of 500 volts, which dropped to 495 volts at the end of the line two and a half miles away. The cars attained a speed of 15 to 18 miles per hour. "Big Fire at Moxham" was the headline in the Saturday March 11, 1893, *Johnstown Tribune* newspaper with $60,000 damage to the car sheds and office of the Johnstown Street Railway Company. Only two motorcars of the 16 and only one trailer car of the 12 housed in the carbarn were saved. The article noted, "At 8 o'clock this morning a telegram was sent to Cleveland and word has been received that ten motor cars and ten trailer cars will be shipped today by express." Until these cars arrive, the surviving cars "will make half hour trips between the Market Street loop and Morrellville, and the train on the Johnstown & Stonycreek Railroad will run between Bedford street and Moxham every 20 minutes."

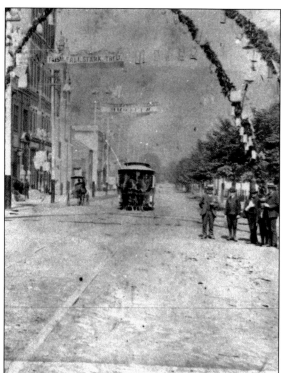

On April 10, 1883, Johnstown Passenger Railway began horsecar operation. This is an early scene of a horsecar at Main and Franklin Streets in downtown Johnstown. The large building on the left was Alma Hall which survived the May 31, 1889, Johnstown flood. (Johnstown Area Heritage Association Archives.)

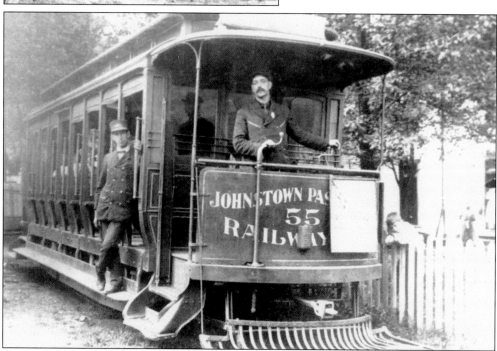

Johnstown Passenger Railway car No. 55 was in the series of cars numbered 50 to 65 built by St. Louis Car Company in 1899. This single truck, single end, eight open bench trolley was at the Dale Loop. On warm summer days open summer cars were a treat to ride. (Johnstown Area Heritage Association Archives.)

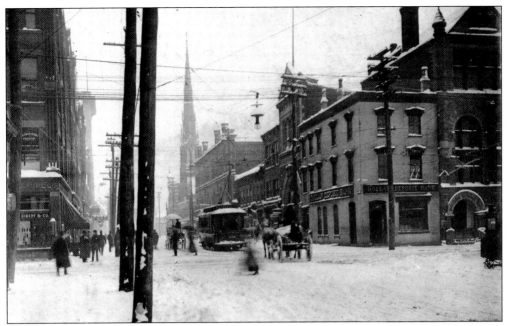

Johnstown Passenger Railway car No. 118, built by Jackson Sharp in 1902, is on Franklin Street at Main Street in this 1905 snow scene. The Dollar Deposit Bank is on the southwest corner, and the Dibert building is on the left. The steeple is the original First Baptist Church. (Johnstown Area Heritage Association Archives.)

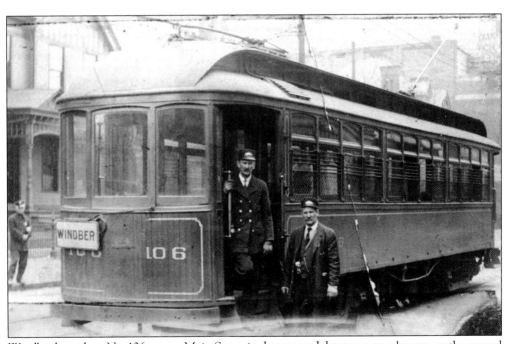

Windber bound car No. 106 was on Main Street in downtown Johnstown on a layover on the second track in front of the Cambria Theatre. This double truck double end car was in the series numbered 101 to 109 built by Stephenson in 1901. (Johnstown Area Heritage Association Archives.)

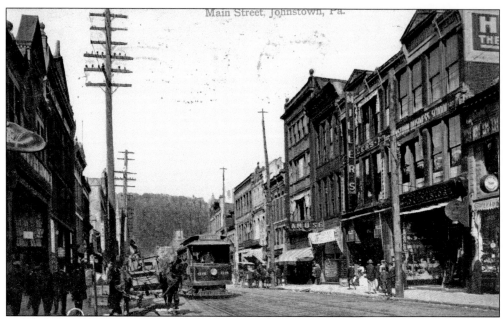

Main Street east of Franklin Street in Johnstown is the setting for a Johnstown Passenger Railway trolley car in this postcard, postmarked January 15, 1910. Electric trolley car service began in Johnstown on November 1, 1890, and the company was reorganized as the Johnstown Traction Company on February 23, 1910. The building on the right is the Zimmerman Building, which is still standing.

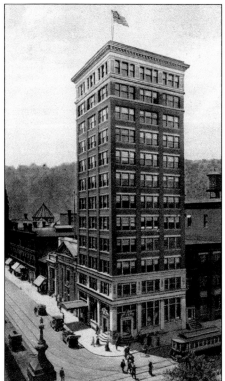

A Johnstown Traction Company trolley car is passing the 12-story First National Bank of Johnstown in this postcard, postmarked September 2, 1918, at Main and Franklin Streets. These were expansion years for the trolley company. Trolley service reached Oakhurst in 1911 and Southmont in 1912. During the late 1970s the bank building was torn down.

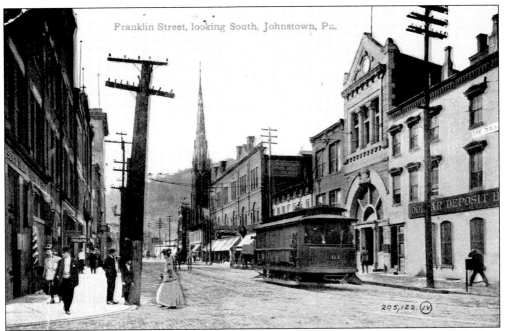

A Johnstown Traction Company trolley car southbound on Franklin Street has just left Main Street in downtown Johnstown in this postcard postmarked October 4, 1911. According to the McGraw Electric Railway List of August 1918, company officials were as follows: president and general manager E. M. DuPont, vice president L. L. Dunham, secretary S. E. Young, and treasurer Joseph McAneny.

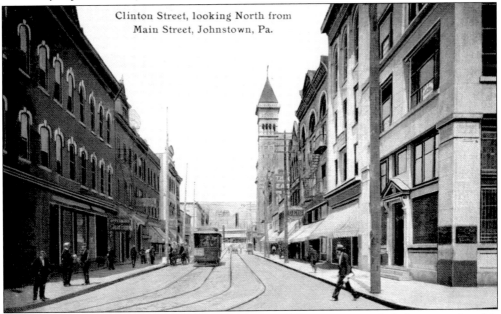

Clinton Street looking north from Main Street in Johnstown provided the scene for this Johnstown Traction Company trolley heading south. By 1918, the Johnstown Traction Company had 35.7 miles of track and operated 72 trolley cars and 34 other cars plus two snow sweepers as noted by the McGraw Electric Railway List of August 1918.

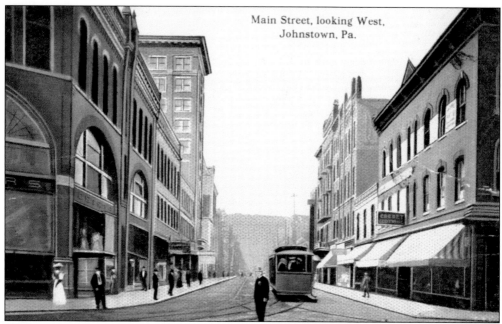

A Johnstown Passenger Railway trolley car has just turned the corner from Clinton Street and is heading west on Main Street in downtown Johnstown in 1905. The system was expanding and within a few years the intersection would feature the street congestion of a thriving downtown area as more areas were served by trolley.

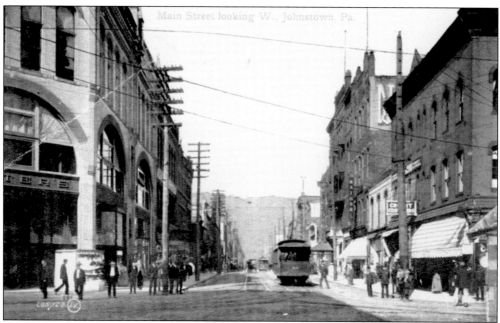

As trolley car systems expanded in the United States, Johnstown Passenger Railway also expanded, as evidenced by this postcard view of more trolley cars passing through Main Street looking west from Clinton Street in 1910. The trolley car was a major factor in strengthening downtown areas and channeling development along transit corridors.

A Johnstown Passenger Railway trolley car has turned from Graham Avenue to Fourteenth Street at the Palace Hotel in Windber in this postcard view. The line from downtown Johnstown via Moxham, Ferndale, and Benscreek was completed to Scalp Level in 1901, and the first trolley car entered Windber on January 1, 1902.

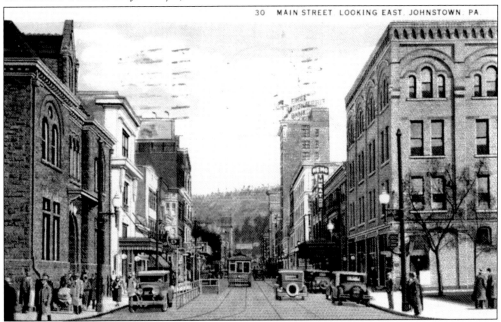

Main Street looking east at Market Street with city hall on the left shows a Johnstown Traction Company car nearing the intersection. By 1931, Johnstown Traction Company was placed into receivership. The March 17, 1936, flood resulted in the conversion of the Windber line to buses. Trolley service was cut back to the Benscreek side of Stonycreek River.

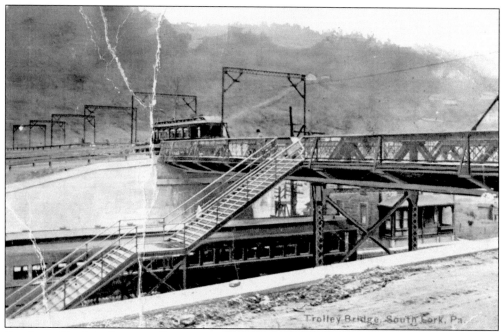

Southern Cambria Railway Company trolley had just arrived at South Fork to provide a convenient transfer point to the Pennsylvania Railroad passenger service to Philadelphia and Pittsburgh. The section from Johnstown to South Fork opened in 1910, and thru service from Johnstown to Ebensburg began January 23, 1912, with an extension later to Nanty Glo. Accidents and growing automobile competition resulted in the last run on December 18, 1928.

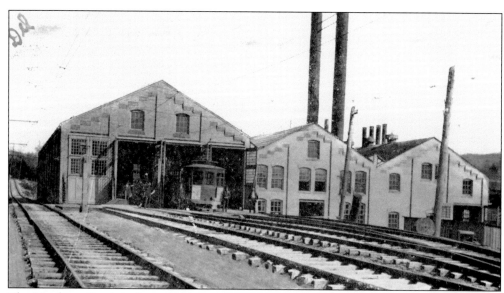

The Northern Cambria Street Railway Company power house and repair shop was located at St. Benedict. The 13-mile line with seven trolley cars connected Patton with Carrolltown, St. Benedict, Spangler, and Barnesboro. Service began in Barnesboro on February 5, 1906, and reached Carrolltown in 1917. The widening of U.S. Highway 219 would have required expensive relocation of trolley trackage from Barnesboro to Spangler. Service was abandoned July 31, 1926.

Two

SYSTEM GROWTH

The *Electric Railway Journal* volume 35 for 1910 reported that the Johnstown Traction Company was incorporated with a capital stock of $500,000 at Harrisburg, Pennsylvania, on February 24, 1910, as the successor to the Johnstown Passenger Railway. Track improvements were made, and a new loop was built at Coopersdale during 1911. During 1919, cars 201 to 205 were purchased from Kuhlman followed by cars 206 to 210 in 1913. Cars 211 to 220 were purchased from St. Louis Car Company in 1916 followed by cars 221 to 230 in 1917. During 1920, second-hand cars were purchased from Salem and Pennsgrove Traction Company and numbered 231 to 236. In 1923 and 1924, second-hand cars were acquired from the Cleveland Street Railway and numbered 237 to 251. In 1924, Kuhlman built cars 301 to 303. During 1928, Johnstown and Somerset Railway car No. 10 was purchased and renumbered 304. Cars were purchased from Bangor Railway and Electric Company and were numbered 305 to 311. Connecticut Company ex-3100 series cars were purchased and renumbered 312 to 318. During 1926, St. Louis Car Company built cars 350 to 369. The March 17, 1936, flood closed all of the trolley lines, and the Windber line was the first line to be converted to bus operation followed by the Dale line on August 2, 1940. The *Johnstown Tribune* newspaper for Saturday, January 25, 1947, reported the Saturday morning arrival of the first Presidents' Conference Committee trolley built by St. Louis Car Company under the headline "Streamlined Trolleys to Provide New Riding Comfort." Car No. 401 was the first of the 17 car order to reach Johnstown on the Baltimore and Ohio Railroad at 5:00 a.m. The article continued, "That their arrival has been eagerly anticipated was evidenced this morning as scores of spectators gathered at the B&O siding to inspect the streamlined beauty." Clyde Altemus, Johnstown Traction Company superintendent of transportation noted that a trainer from Pittsburgh Railways Company would instruct operators and inspectors. Ridership peaked at 24,722,124 in 1947, which was the first year of Presidents' Conference Committee car operation.

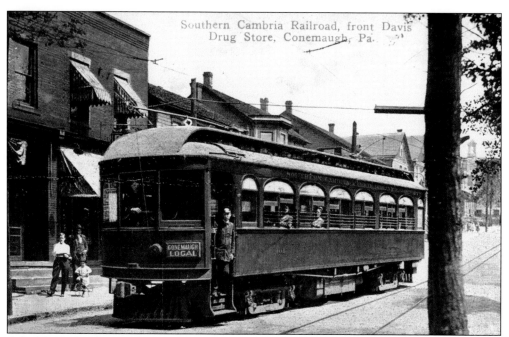

A Southern Cambria Railway trolley car poses at the Davis Drug Store at Main and First Streets in Conemaugh. This car was ordered during 1909 from the Niles Car Company. Weighing 27,000 pounds, the wood bodied car with a semi-steel under frame was 48 feet long and 8.83 feet wide. With a seating capacity of 50, the car featured a mahogany interior trim and plush leather seats. (Cover Studio Photography.)

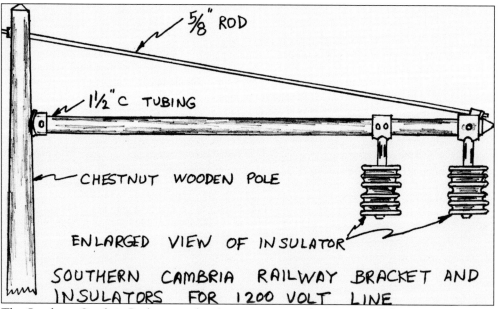

The Southern Cambria Railway overhead system consisted of two parallel No. 0000 grooved trolley wires spaced six inches apart. Pole spacing on the private right-of-way was about 90 feet but closer at curves and where conditions demanded closer spacing. Lengths of poles varied from 30 to 35 feet, and poles were buried six feet into the ground.

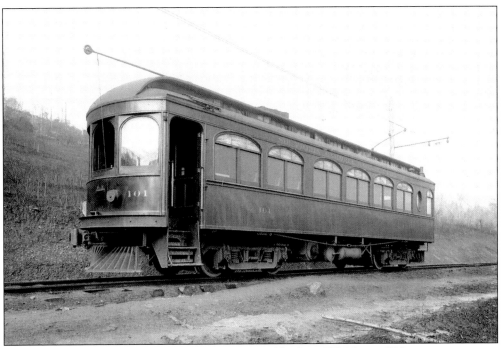

Southern Cambria Railway car No. 101 was powered by four GE205 type 75 horsepower motors with General Electric gears and pinions. The car had a General Electric control system, Lindstrom hand brakes, Symington journal boxes, Baldwin model 78-25 trucks, Symington center bearings, Nichols-Lintern sanders, Knutson trolley retrievers, Niles couplers, Niles car trimmings, Niles gongs, and Niles ventilators. (Harold Jenkins photograph.)

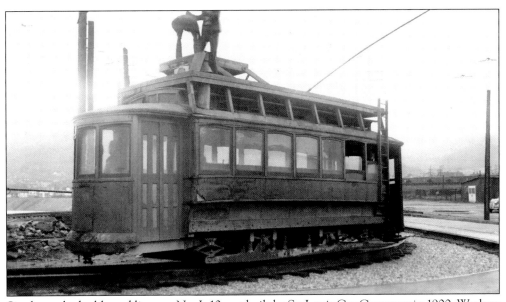

Single truck, double end line car No. L-10 was built by St. Louis Car Company in 1900. Workers were installing overhead wire at the turn from Broad Street to the Coopersdale Bridge at the wire mill. These were years of expansion for Johnstown Traction Company.

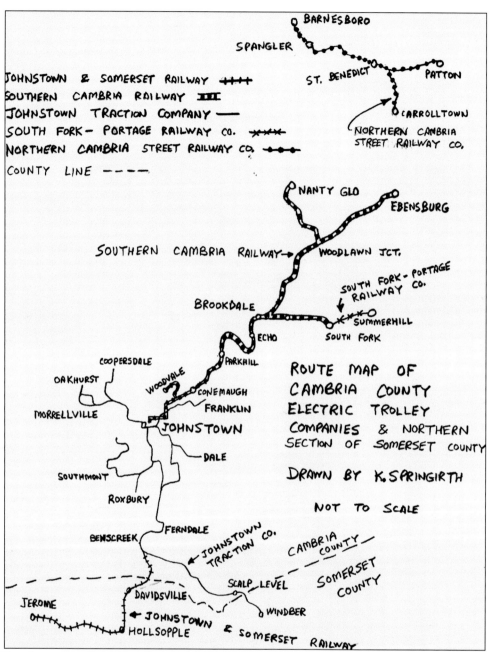

The above map shows Cambria County electric trolley lines. Johnstown Traction Company served the metropolitan Johnstown area and operated into northern Somerset County serving Windber. Johnstown and Somerset Railway used the Windber line of Johnstown Traction Company and branched off serving Davidsville, Hollsopple, and Jerome. Southern Cambria Railway connected Johnstown with South Fork, Ebensburg, and Nanty Glo. South Fork-Portage Railway operated from Summerhill to South Fork where it connected with the Southern Cambria Railway. Northern Cambria Street Railway Company linked Patton, Carrolltown, St. Benedict, Spangler, and Barnesboro and was never connected with the other electric trolley lines in Cambria County.

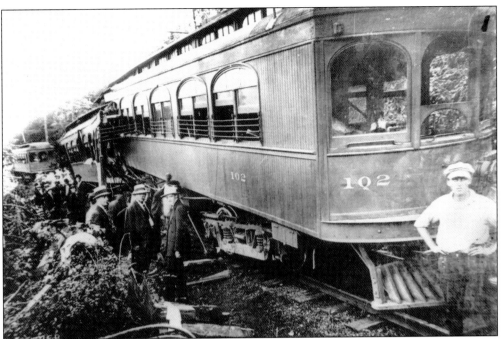

On Saturday, August 12, 1916, at 10:45 a.m. Southern Cambria Railway car No. 102 collided head on with No. 104 between the villages of Echo and Brookdale. The August 12, 1916, *Johnstown Tribune* newspaper reported, "Employees of the Southern Cambria Railway at the Brookdale barns were startled when the city bound car dashed past without stopping." The August 14, 1916, *Johnstown Tribune* newspaper reported the death toll had reached 26. (Johnstown Area Heritage Association Archives.)

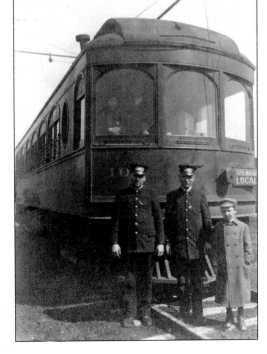

A Southern Cambria Railway trolley handled the Conemaugh local assignment at Conemaugh. The section of the line from Johnstown to South Fork was built on hillsides and followed the course of the Conemaugh River. Grades and curves were very severe and numerous. The roadbed was well ballasted with granulated blast furnace slag. (Johnstown Area Heritage Association Archives.)

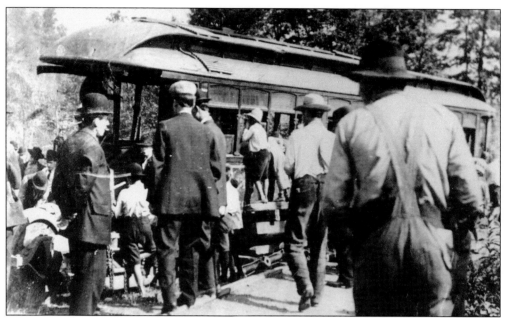

The Thursday evening, July 16, 1908, *Johnstown Tribune* newspaper headlined, "One Killed and Forty Injured in Windber Street Car Wreck." Windber streetcar No. 104 collided with a Baltimore and Ohio train at the Ferndale crossing. According to the newspaper account, the car went into reverse and traveled the grade into Ferndale, hit the curve, and went over on its side. Rescuers arrived promptly and within 30 minutes everyone was out of the car. (Johnstown Area Heritage Association Archives.)

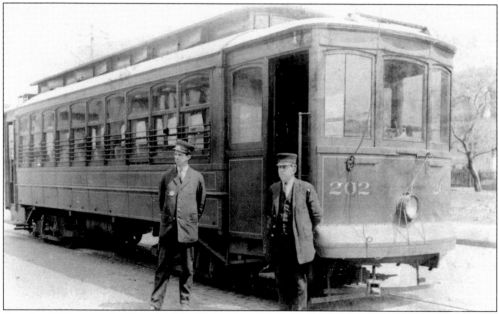

Car No. 202 was a double truck, double end trolley built by Kuhlman Car Company in 1911. This car had a manually operated sliding door. These were expansion years for the company as the Southmont line opened on June 29, 1912. The series 201–205 cars were scrapped by 1945. (Johnstown Area Heritage Association Archives.)

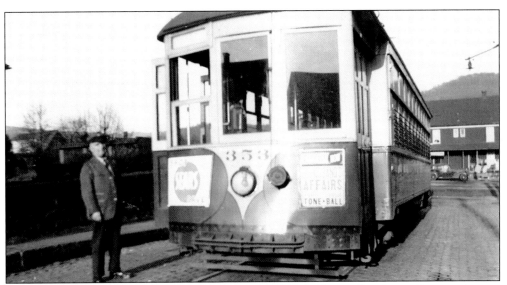

Johnstown Traction Company car No. 353 was on the Oakhurst Shuttle on Corrine Avenue at Daniel Street. A Packard automobile can be noted in this 1930s scene. At its peak, the Oakhurst Shuttle had service every 12 minutes during rush hours and off-peak service every 15 minutes during the day. Sunday and evening service was every 16 minutes. (Johnstown Area Heritage Association Archives.)

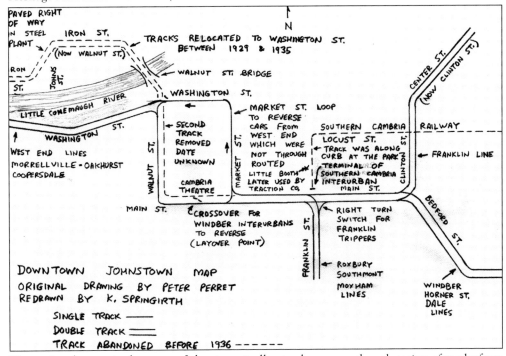

The major changes in downtown Johnstown trolley trackage were the relocation of tracks from Iron Street (now Walnut Street) to Washington Street for the Morrellville and Coopersdale trolley lines, the abandonment of the second track on Walnut Street from Washington to Main Streets, the removal of the second track on Main Street from Walnut Street to Market Street, and the removal of Southern Cambria Railway trackage after its abandonment.

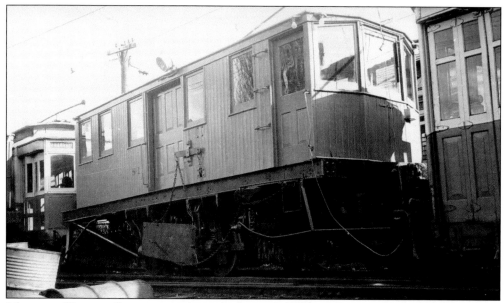

Johnstown Traction Company single truck, flat roof, double end snow sweeper No. S1, built by McGuire, was at Moxham Car Barn. Winters in the mountains of western Pennsylvania can be quite cold and snowy. At its peak there were four snow sweepers. All of the company's snow sweepers were scrapped by 1953.

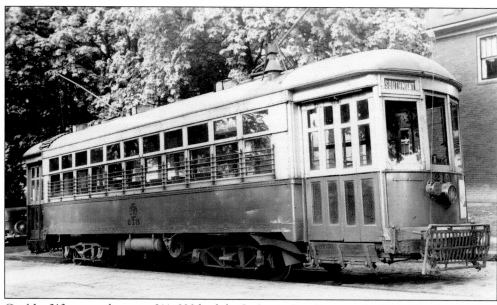

Car No. 213 was in the series 211–220 built by St. Louis Car Company in 1916. The double truck double end arch roof car is at the end of the picturesque Southmont line on May 27, 1940. By 1959, all of the cars of this series were scrapped as ridership declines reduced the number of cars needed. At its peak Southmont had service every 30 minutes from early morning to midnight.

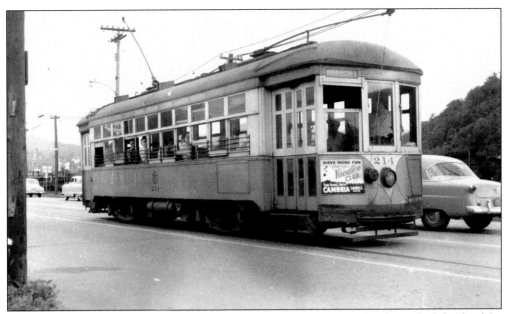

Car No. 214 was on Broad Street heading for Moxham Car Barn. Immediately on the left side of the car is a Nash automobile. This car was in the 211–220 series built by St. Louis Car Company in 1916. Broad Street served the west end trolley lines of Morrellville–Oakhurst Shuttle and Coopersdale.

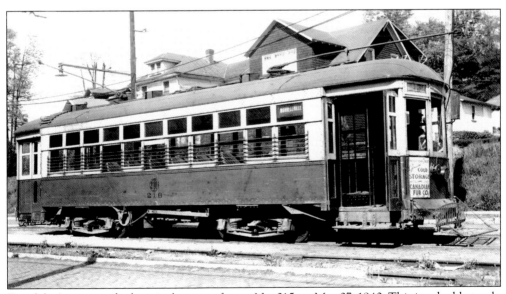

Ferndale Avenue at the loop is the scene for car No. 215 on May 27, 1940. This is a double truck, double end car built by St. Louis Car Company in 1916. Ferndale was a cut back for the Windber line. Daily service to Ferndale from Johnstown was every 12 minutes, and beyond that point to Windber service was every 40 minutes.

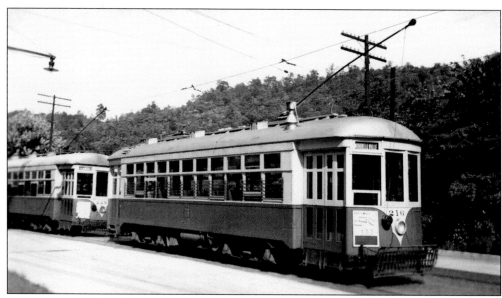

Trolley No. 216 at Ferndale Loop was a double truck double end car built by St. Louis Car Company in 1916. Cars in the series 211–220 were scrapped by 1959. At its peak on Monday through Saturday the first car left Ferndale Loop at 5:54 a.m. and the last car left at 12:30 a.m. On Sunday the first car left Ferndale Loop at 6:06 a.m. and the last car at 12:18 a.m. Daily service frequency was every 12 minutes.

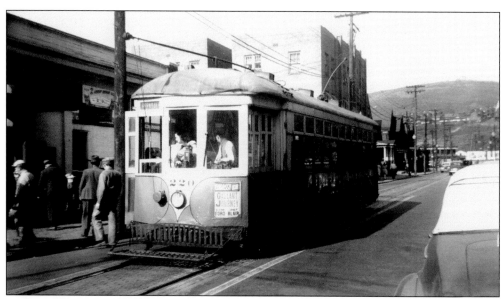

In this 1940s scene, car No. 220 is unloading passengers at Walnut Street at the corner of Main Street in downtown Johnstown. This is a double truck double end trolley car built by St. Louis Car Company in 1916. The 211–220 series of cars had a length over bumpers of 41.4 feet, 26 inch wheel diameter, and a 4.5 inch axle journal diameter.

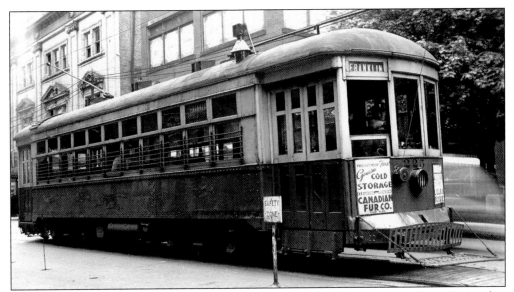

Double truck, double end car No. 225 was at Main and Market Streets on May 27, 1940. A safety island for transit riders was later built at this location. This car was in the series 221–230 built by St. Louis Car Company in 1917. Cars in this series were scrapped by 1959.

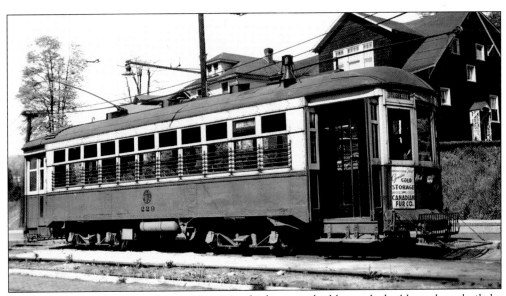

Ferndale Loop is the scene for car No. 229, which was a double truck double end car built by St. Louis Car Company in 1917. On the front of the trolley is a sign advertising Canadian Fur Company, which was a local Johnstown business that is no longer in existence.

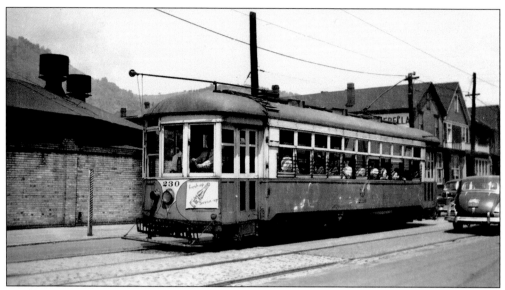

Double truck, double end car No. 230 is on Maple Avenue in Woodvale on the Franklin line inbound for downtown Johnstown. In 1917, St. Louis Car Company built the double truck, double end 221–230 series of cars, which were scrapped by 1959.

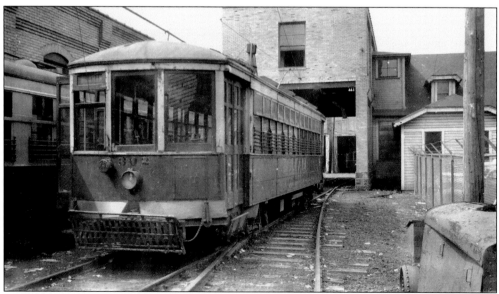

Car No. 302 was at the Moxham Car Barn in the 1940s and was used on the Windber line. Kuhlman Car Company built this double truck, double end car in 1924. The car was later repainted the same front striping as shown on car No. 303 on page 31. Cars in the series 301–303 were scrapped by 1957.

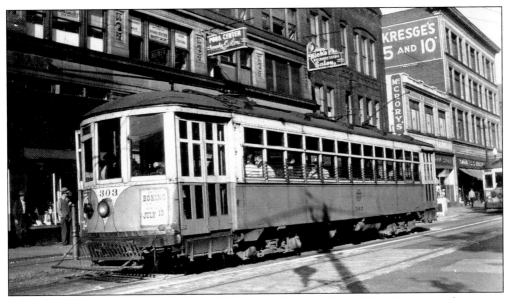

Johnstown Traction Company car No. 303 is at Main and Franklin Streets in downtown Johnstown. This location was a main transfer point for all of the trolley lines. Kuhlman built car series 301–303 in 1924 for the Windber line. Following the abandonment of the Windber line this series of cars was used in rush hour trip service.

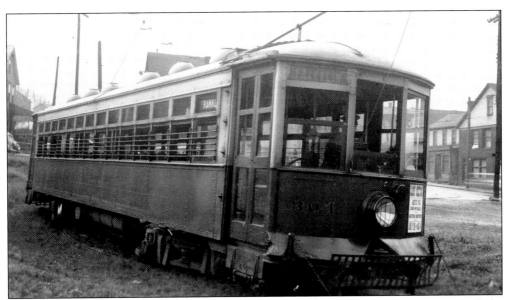

Car No. 304 is seen at the Franklin Loop. This double truck, double end car was built by Kuhlman Car Company in 1922 as car No. 10 for the Johnstown and Somerset Railway, and was purchased by Johnstown Traction Company in 1928. Through service every two hours (from Johnstown to Jerome using the Johnstown Traction Company line to Kelso and Johnstown and Somerset Railway line to Jerome) began October 1, 1922.

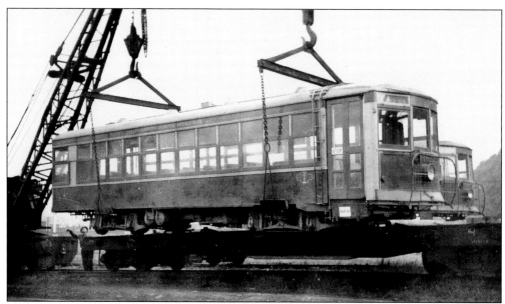

This is one of seven double truck Birney cars that had been purchased from Bangor Railway and Electric Company during World War II and is being unloaded from the railroad car. This series of cars was built by Wason in 1922 and became Johnstown Traction Company car series 305–311. Car No. 311 is the only survivor and can be seen at the Rockhill Trolley Museum in Rockhill, Pennsylvania.

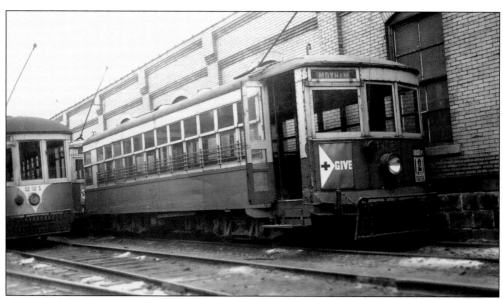

Johnstown Traction Company car No. 305, which had been purchased from the Bangor Railway and Electric Company of Bangor, Maine, was at the Moxham Car Barn next to car No. 221. The car weighed about 28,000 pounds and seated 44 passengers. ACF Brill trucks were used to achieve a low floor design with 26-inch wheels.

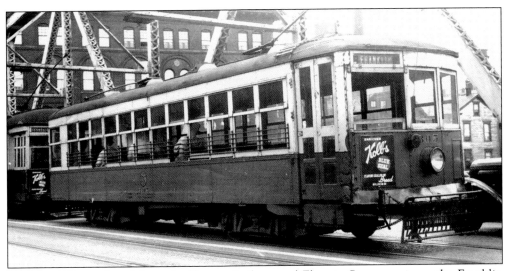

Car No. 305, purchased from the Bangor Railway and Electric Company, is on the Franklin Street bridge over the Stonycreek River with the Conrad Building in the background. The Roxbury and Southmont trolley lines used this trackage. The car had four General Electric model 258 Form C motors and a 14-inch gong operated by foot.

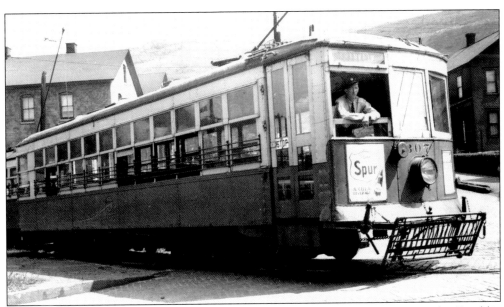

Car No. 307, purchased from the Bangor Railway and Electric Company, is at the Franklin Loop. This car had Simplex trolley bases. The car ahead of it was an ex-Windber car that was used in Franklin trip service that would leave Moxham Car Barn at 2:00 p.m. for the 3:00 p.m. shift changes. At its peak, daily service on the Franklin line was every 10 minutes.

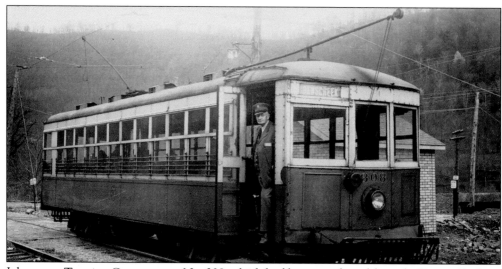

Johnstown Traction Company car No. 308, which had been purchased from the Bangor Railway and Electric Company, is at the Ferndale loop on the Benscreek track. The car had Consolidated Car Company type 392 cross heaters and Golden Glow type SM95 headlights. Benscreek was a cutback point on the Windber line.

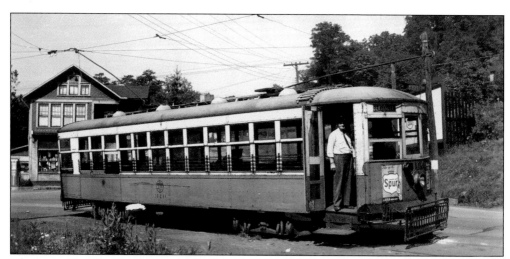

Johnstown Traction Company car No. 310, which had been purchased from the Bangor Railway and Electric Company, was at the end of the Benscreek line. The March 17, 1936, flood severely damaged the Windber line, and the decision was made to cut the line back to Benscreek. Bus service was then operated to Windber.

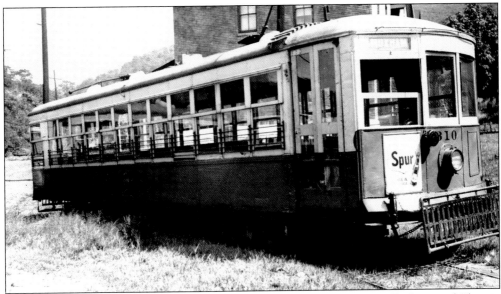

Johnstown Traction Company car No. 310, purchased from the Bangor Railway and Electric Company, is at the Franklin Loop. During shift changes, the Franklin Loop was a busy spot for the trolleys carrying a large number of workers to and from the steel mills. Franklin cars used Clinton Street, Atwood Street, Maple Avenue, River Avenue, Locust Street, and Main Street to the loop at Main and Bon Air Streets.

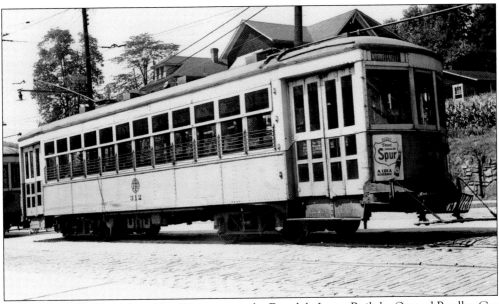

Double truck double end car No. 312 is seen at the Ferndale Loop. Built by Osgood Bradley Car Company for the Connecticut Company (Hartford Division) as a 3100 series car in 1924, it was one of seven cars purchased by Johnstown Traction Company during World War II, which were renumbered 312–318. All cars of this series were scrapped by 1947.

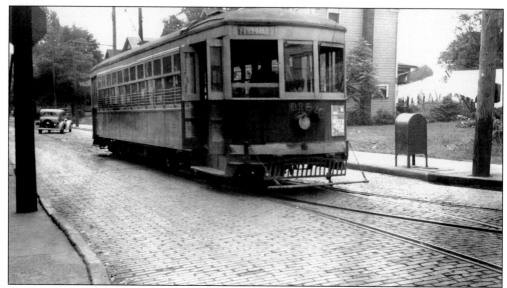

Car No. 312, an ex-Connecticut Company (Hartford Division) 3100 series car built by Osgood Bradley Car Company in 1924, is turning from Chandler Avenue onto Strayer Street in Morrellville. The track coming off in the lower right portion of the picture was for the Oakhurst shuttle. The wide loop through Morrellville contributed to heavy passenger loading for this line.

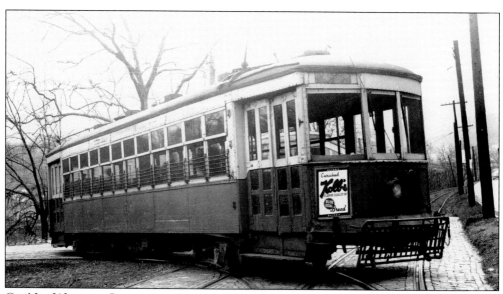

Car No. 313, an ex-Connecticut Company (Hartford Division) 3100 series car built by Osgood Bradley Car Company in 1924, is seen at the Ferndale Loop. The track going off to the right in the background was heading to Benscreek. Ferndale cars used Franklin Street, Valley Pike, Central Avenue, and Ferndale Avenue.

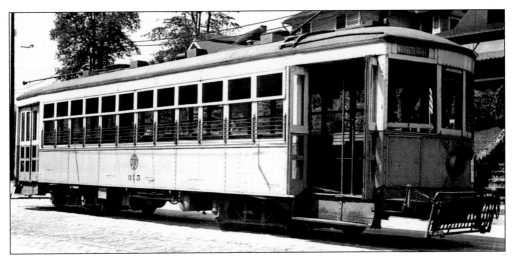

Car No. 315, an ex-Connecticut Company (Hartford Division) 3100 series car built by Osgood Bradley Car Company in 1924, is on Ferndale Avenue. Johnstown Traction Company rule No. 64 noted, "Motormen must regulate the speed of cars so as to conform with the time and card as nearly as possible, and not lose time on one portion of the road and make it up on the other."

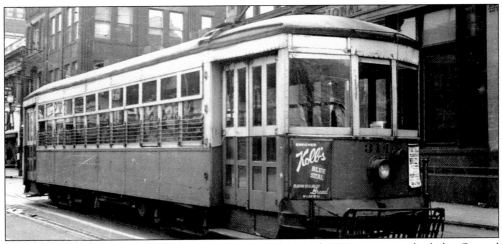

Car No. 314 ex-Connecticut Company (Hartford Division) 3100 series car built by Osgood Bradley Car Company in 1924 is in downtown Johnstown at Main and Franklin Streets, which was a main transfer point. Johnstown Traction Company rule No. 67 noted, "Motormen must keep their cars properly spaced, and when in motion not less than one hundred feet apart."

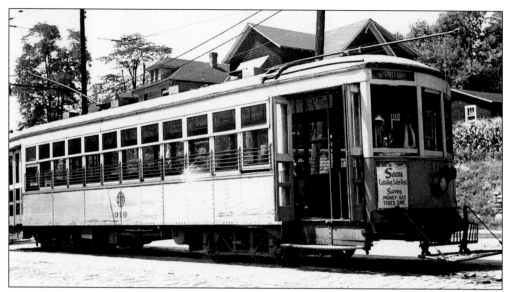

Car No. 316 ex-Connecticut Company (Hartford Division) 3100 series car built by Osgood Bradley Car Company in 1924 is on Ferndale Avenue at the loop. Johnstown Traction Company rule No. 71 noted, "Except in cases of emergency, brakes must be applied gradually, so as not to throw standing passengers. When stopping, release the brake a little, so as to make an easy stop."

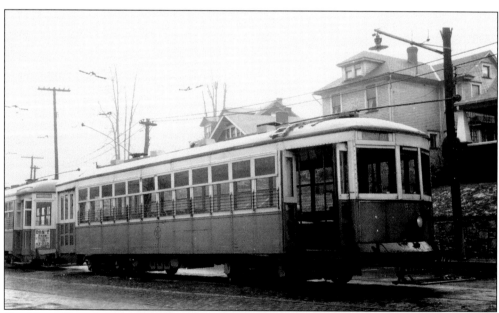

Car No. 318 ex-Connecticut Company (Hartford Division) 3100 series car built by Osgood Bradley Car Company in 1924 is on Ferndale Avenue north of the loop. Johnstown Traction Company rule No. 75 noted, "Motormen must never leave the platform of the car without taking controller handle with them, throwing off over head switch, and applying brakes."

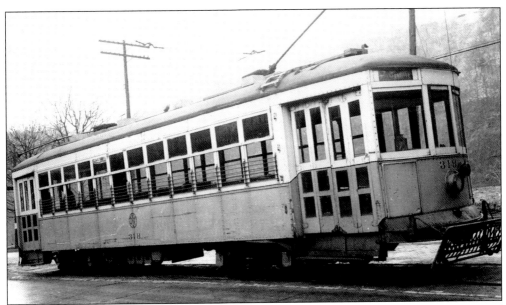

Car No. 318, an ex-Connecticut Company (Hartford Division) 3100 series car built by Osgood Bradley Car Company in 1924, is at Ferndale Loop. Operator rules followed large system regulations. Johnstown Traction Company rule No. 79 noted, "Motormen must keep the headlight glass clean and see that the headlight is properly lighted when the car is running on the road after dark."

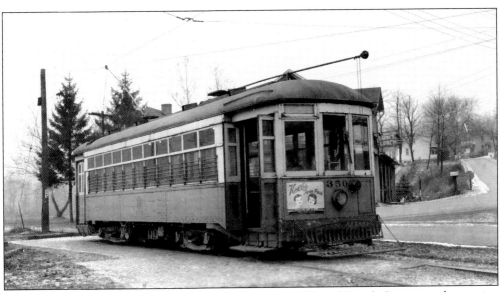

Double truck, double end car No. 350 is at the original Crystal Beach Station at the passing siding on the Benscreek line. This car was in the series 350–354 built by St. Louis Car Company in 1926. These durable cars had heavy steel framing, and the side sections below the windows were fabricated like a bridge section. This car is now at the Pennsylvania Trolley Museum.

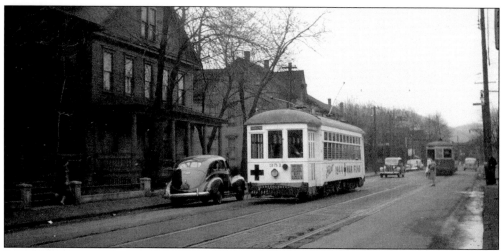

Painted as a Red Cross blood drive car during World War II, car No. 351 is on Franklin Street at South Street on March 16, 1944. The June 1, 1961, *Johnstown Tribune-Democrat* reported that Herbert Redlich of Fullerton, California, purchased the car as a hobby. The Market Street Railway of San Francisco has now preserved this sturdy and reliable car with its rattan seats and cherry wood interior.

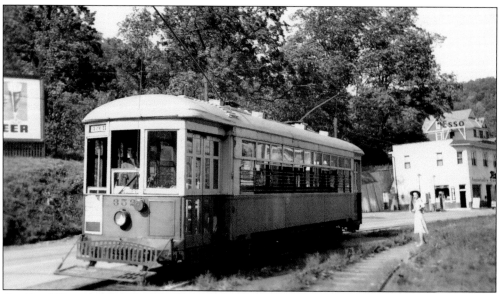

Car No. 352 is at the end of the line at Benscreek at the passing siding. St. Andrews Church now occupies the site. This car had been preserved at the National Capitol Trolley Museum at Colesville, Maryland, but was destroyed in a fire Sunday, September 28, 2003, that destroyed eight trolleys.

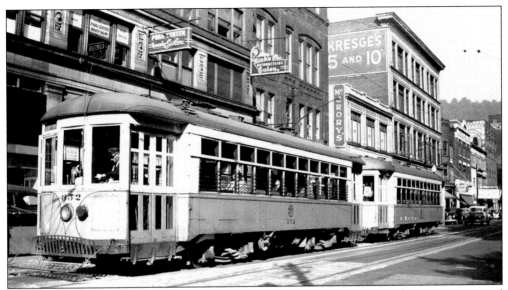

Double truck, double end car No. 352 is at Main and Franklin Streets. This car was painted Omaha Orange and Panama Sand with a gray roof, black undercarriage, and black striping. St. Louis Car Company built the cars numbered 350–369, which were mainstays of the system for many years.

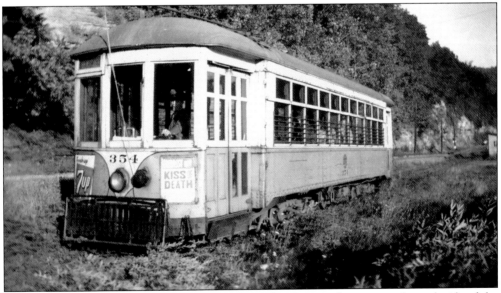

Car No. 354 was at Benscreek at the Riverside Bridge. Benscreek was a single track side of the road line that was a short surviving section of the Windber line retained after the March 17, 1936, flood. It was operated as a one car shuttle from the end of the Ferndale line that operated during peak hours.

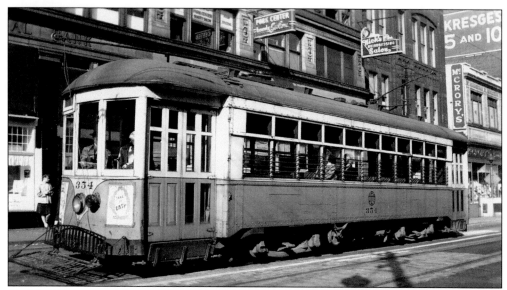

Car No. 354 is seen at Main and Franklin Streets. This car represented a typical small town and small city United States trolley car. It was designed and built as a quality car by St. Louis Car Company in 1926 to provide dependable service for the riding public. This car has been scrapped.

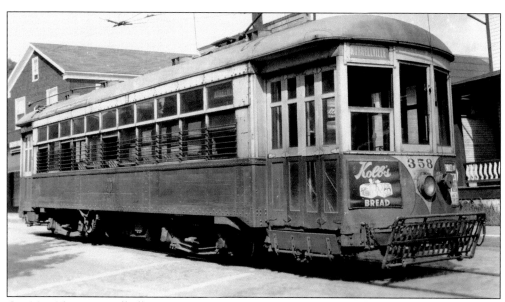

Car No. 358 at Morrellville was part of the series 355–359 built by St. Louis Car Company in 1926. This series of cars was converted to double end operation. This car was purchased by Stone Mountain Scenic Railroad and was later sold to the Trolley Museum of New York State.

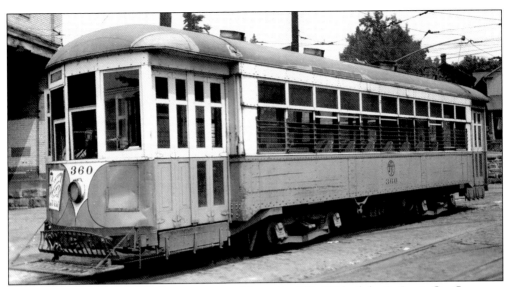

Car No. 360 at Moxham Car Barn was part of the series 360–369 built by St. Louis Car Company in 1926. This car was primarily used on the Horner Street line. A radio telephone was used so that the motormen could talk to each other to schedule meets, because there were only two passing sidings, one on Horner Street at Messinger Street and the other on Ash Street at Grove Avenue.

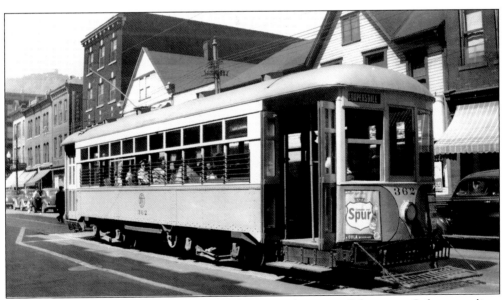

Car No. 362 is at Market and Washington Streets in downtown Johnstown. Safety zone lines had been painted at this location to improve passenger safety amid the growing use of motor vehicles. This car is now at the Fox River Trolley Museum at South Elgin, Illinois. Cars 350 to 369 represented the classic 1920s United States trolley car design.

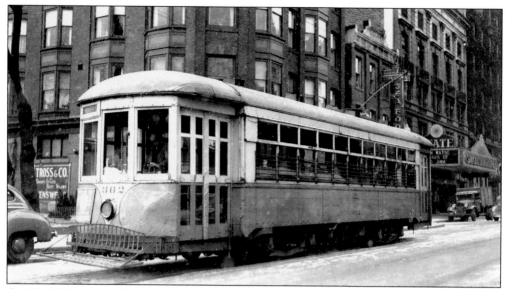

Car No. 362, built by St. Louis Car Company, is at Main and Market Streets. The building on the right is the State Theatre, which is now part of Lee Hospital. The little brick building is the traction company waiting room. Cars 350 to 354 were double end, cars 355 to 359 were single end converted to double end, and cars 360 to 369 were single end cars.

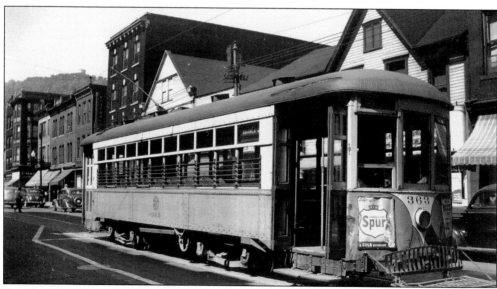

Car No. 363 built by St. Louis Car Company is at Market and Washington Streets in downtown Johnstown. The car seated 44 passengers and had St. Louis model EDJ64 trucks. This car was scrapped. Cars 350 to 369 had rounded ends, straight sides, and the trucks were equipped with SKF roller bearings.

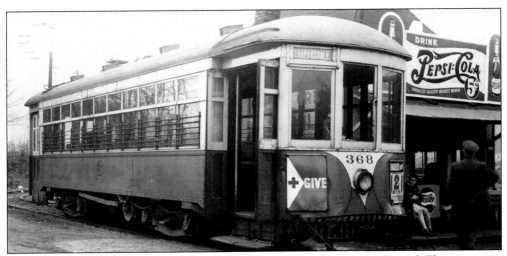

Car No. 368 is at Roxbury Loop where there was a pagoda-style concession stand. This car was in the series 360–369 built by St. Louis Car Company in 1926. All of the cars in this series have been scrapped, except No. 362, which is at the Fox River Trolley Museum in South Elgin, Illinois.

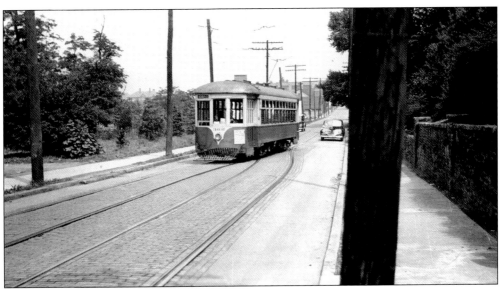

Car No. 368 is on Ash Street at Grove Avenue on the Horner Street line on September 1, 1939. The neighborhood was and still is called Sunnyside. Horner Street cars used Main Street, Baumer Street, Horner Street, Messinger Street, Ash Street, Grove Avenue, Dupont Street, and Central Avenue to Bond Street.

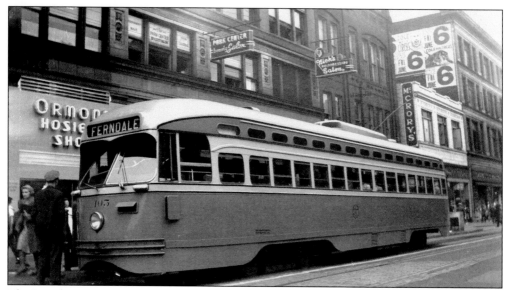

The Presidents' Conference Committee car No. 405 is at Main and Franklin Streets in the early 1950s. Although this type of trolley only lasted 13 years in Johnstown, there are still small fleets of these cars left in the United States in the year 2006. The Ormond Hosiery and Shoes store shown on the left side of the picture is no longer in existence.

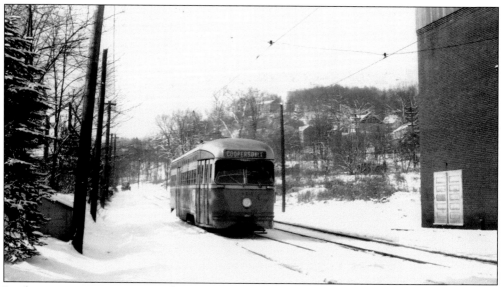

In the winter-time snow, Presidents' Conference Committee car No. 413 is heading north from Roxbury Loop with the Roxy Theatre building on the right on February 22, 1948, having completed about one year of service. Roxbury cars from downtown Johnstown used Franklin Street and Roxbury Avenue to the loop at Roxbury Park.

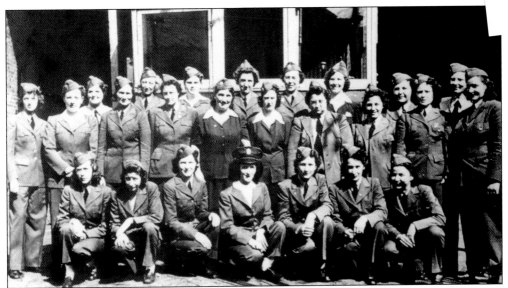

Johnstown Traction Company female operators during World War II from left to right are (first row) Manana Britton, Emma Howard, Irene Trosan, Josephine Zellermeyer, Mary Mavri, Jean Slezak, and Mary Hayden; (second row) Cora Steinberg, Dorothy Adams, Margaret Burkett, Marie Ford, Alice Keifer, Mabel Thomas, Margaret Laird, Helen Kwaitkowski, Elizabeth Rosbaugh, and Flora Thompson; (third row) Elsie Schuster, Elenore Hohman, Thelma Mangus, Alice Barchey, Jane Penrod, Hazel Fiddler, Esther Hartnett, and Daisy May Brosch. (Cambria County Transit Authority.)

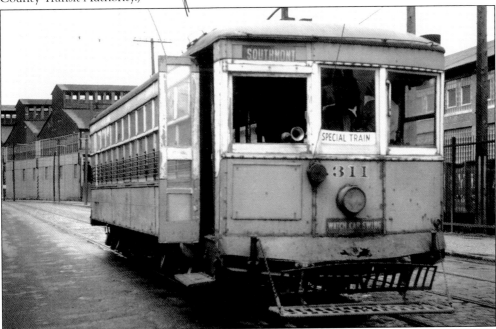

Double truck, double end Birney safety car No. 311 is on the Franklin line at Center Street (now Clinton Street) with the Gautier Works of Bethlehem Steel in the background on May 30, 1960. At that time, No. 311 was the last Birney type trolley car operating in a United States city in regular public transit service. (Kenneth C. Springirth photograph.)

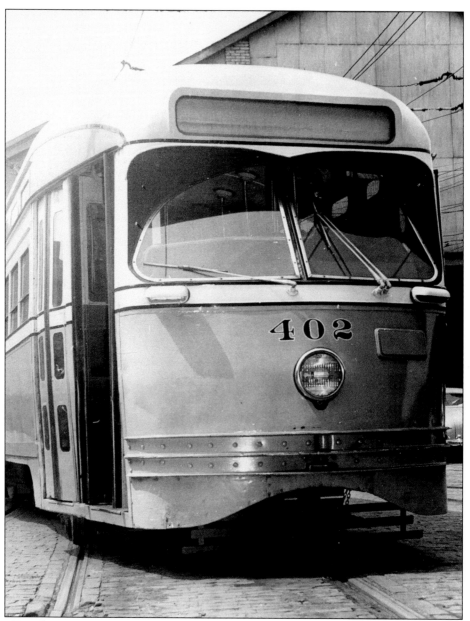

The Presidents' Conference Committee car No. 402, shown at Moxham Car Barn, was part of a 17 car order built by St. Louis Car Company for Johnstown Traction Company and went into service during January 1947. Costing about $22,000 each, the car had leather covered seats for 50 passengers. For passenger comfort, each window was opened and closed by a small hand crank similar to that used on an automobile. There was a comfortable seat for the operator who controlled operation by a series of switches and floor pedals. The car was electrically heated. For standees there was a post at each seat to hold onto and windows at the top of the car for standing passengers to look out. With a full passenger load, this type of car could get up to top speed at a faster rate than the other cars. Cruising speed was about 42 miles per hour, and maximum speed on a level area was 50 miles per hour. A dynamic brake reduced speed. A drum brake stopped the car. Track brakes were used in an emergency. (James E. Parks photograph.)

Three

ABANDONMENT OF TROLLEY CAR SERVICE

On December 5, 1931, the Pennsylvania Public Service Commission approved the Johnstown and Somerset Railway Company's request to discontinue trolley service between Jerome and Kelso in Somerset County. The first Johnstown Traction Company abandonment occurred when the line to Windber was not rebuilt after the March 17, 1936, flood. A portion of that line continued to operate from Ferndale to Benscreek. The line to Dale was converted to bus operation on August 2, 1940, because of a street reconstruction project. On November 20, 1951, the Horner Street line was converted to trackless trolley operation because many portions of the line were single track. When the Westmont bus line was combined with the Southmont route after bus operation via the Westmont incline ceased, Southmont trolley service had been reduced to a once-a-day franchise run. Southmont was a single track line largely along the side of the road that traversed a steep grade. The Southmont line, which was a branch of the Roxbury line, was abandoned in 1954 when slides blocked a portion of the line. The side of the road Benscreek shuttle that operated during peak hours from Ferndale to Benscreek was abandoned during 1957. The last car to use the Benscreek line was trolley No. 350, which used a portion of the line to a temporary loading ramp where it was transported via truck to the Arden Trolley Museum. Several trolley excursions used a portion of the line until 1959. The Ferndale line was converted to bus operation on November 25, 1959. This was necessitated by the need for repairs where the line crossed the Baltimore and Ohio Railroad tracks. The railroad requested that the crossing be repaired or removed. Johnstown Traction Company removed the crossing and replaced the trolleys with buses. The Ferndale line was a connection between Moxham Car Barn and the rest of the system so this section remained for cars to and from the carbarn. Shortly before the end of all trolley service, Coopersdale was changed to bus operation to permit work on installation of trackless trolley wire. Trolley car service was now confined to the Roxbury-Morrellville line and rush hour service to Franklin with cars using the Ferndale line to and from Moxham Car Barn. Johnstown trolley car service ended on June 11, 1960.

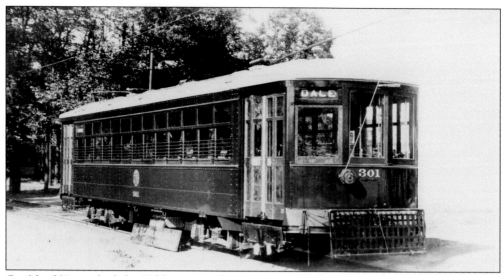

Car No. 301 was built by Kuhlman Car Company in 1924 for the Windber line and following closure of this line was assigned to rush hour trip service. At 10:00 a.m. Friday, August 2, 1940, the last run was made on the Dale trolley line. Daniel Forrest operated the last trolley on the line, which was converted to bus operation due to construction of a sanitary sewer on Bedford Street.

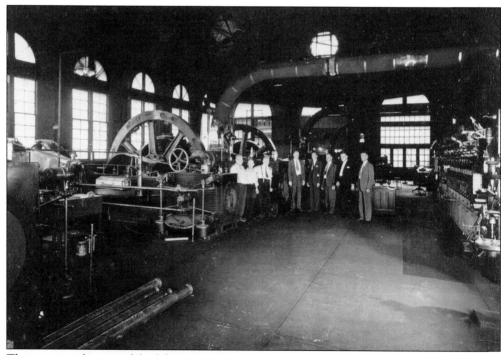

This is an inside view of the Johnstown Traction Company Baumer Street Power House. In the May 25, 1989, *Johnstown Tribune-Democrat* it was noted that power generation at this facility was discontinued early in 1946, with power then purchased from Pennsylvania Electric Company. The building was demolished in 1989. (Harold Jenkins photograph.)

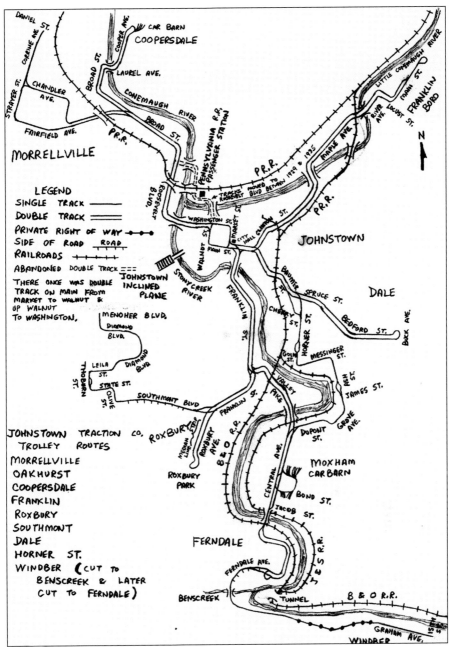

The 1924 McGraw Electric Railway Directory listed Johnstown Traction Company with 43 miles of track and 72 trolley cars plus five buses. Following abandonment of the Windber line in 1936 and Dale in 1940, the system remained intact until the abandonment of Horner Street in 1951. Southmont was abandoned in 1954 followed by Oakhurst in 1958, Ferndale in November 1959, and final closure on June 11, 1960. At the end of World War II, the system had 68 trolley cars, but at the time of closure, 27 trackless trolleys handled service requirements. Ridership for both 1957 and 1958 was 6.2 million, but a 116 day steel strike contributed to a decline to 5.45 million in 1959. In 1960, the last year of rail operation, ridership was 5.83 million but dropped to 4.83 million in 1961.

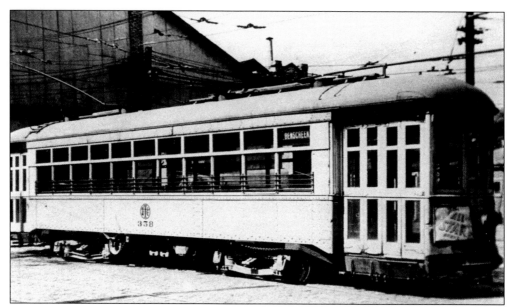

Johnstown Traction Company car No. 358 is at Moxham Car Barn in this 1957 scene. After trolley car operation closed in Johnstown on June 11, 1960, this car was later acquired by Stone Mountain Scenic Railroad at Stone Mountain, Georgia. A Detroit Diesel engine and a truck transmission replaced the electric motors and controls. Renumbered as No. 1910, it was used until the 1980s and was acquired by the Trolley Museum of New York State, where it is currently being rebuilt. Other surviving Johnstown trolleys are as follows: No. 351 Market Street Railway at San Francisco, California; No. 311 and No. 355 Rockhill Trolley Museum at Rockhill/Orbisonia, Pennsylvania; No. 356 and No. 357 Shore Line Trolley Museum at East Haven, Connecticut; and No. 362 Fox River Trolley Museum at South Elgin, Illinois. Car No. 352 was destroyed in the September 28, 2003, carbarn fire at the National Capital Trolley Museum at Colesville, Maryland. (James E. Parks photograph.)

A Johnstown Traction Company transfer was good only at the junction or intersection of the issuing line and within the time limit. Under Pennsylvania state act of the assembly, a transfer could only be used by the person to whom it was issued.

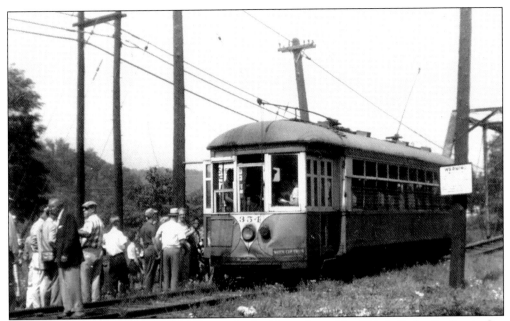

Johnstown Traction Company double truck, double end car No. 354, built by St. Louis Car Company in 1926, is southbound on the Ferndale line at the Baltimore and Ohio Railroad crossing just south of the bridge over Stonycreek River on a rail enthusiast excursion on September 6, 1959. (Edwin A. Wilde photograph.)

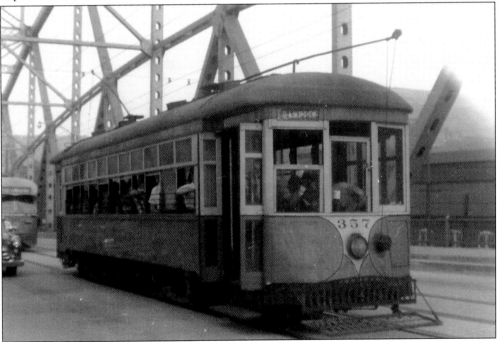

Car No. 357 is on the Maple Avenue bridge on the Franklin line on September 6, 1959. A 1926 product of St. Louis Car Company and currently at the Shore Line Trolley Museum at East Haven, Connecticut, the car has four Westinghouse WH-510A2 motors, weighs 38,000 pounds, and seats 44 passengers. (Edwin A. Wilde photograph.)

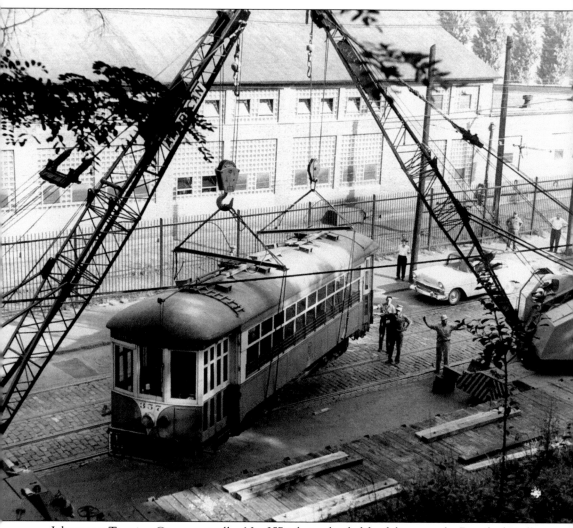

Johnstown Traction Company trolley No. 357 is being loaded for delivery to the Branford Trolley Museum, which is today known as the Shore Line Trolley Museum located at East Haven, Connecticut. Built by St. Louis Car Company in 1926 as a single end car, it was later converted into a double-ended car. Peter Perret, retired Cambria County reference librarian, who obtained this picture from the *Johnstown Tribune-Democrat* after 1959, noted that the location was on Center Street, which is now known as Clinton Street, at the Pennsylvania Railroad freight house. (Photograph courtesy of the Tribune-Democrat, Johnstown, Pennsylvania.)

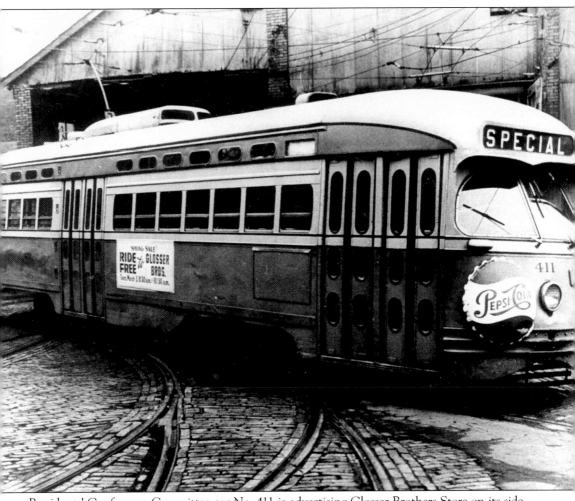

Presidents' Conference Committee car No. 411 is advertising Glosser Brothers Store on its side at Moxham Car Barn. Johnstown Traction Company was the smallest United States transit system to order Presidents' Conference Committee cars. The design of Johnstown's 17 Presidents' Conference Committee cars had its beginnings in December 1929, when executives of a number of transit companies met in Chicago and organized the Presidents' Conference Committee. Recognizing the need for a trolley car that could compete with the automobile, the Presidents' Conference Committee appropriated money, hired engineers, designed, built, and tested a new trolley that was pleasing to ride plus provided good performance at a reasonable cost. The first production Presidents' Conference Committee car was delivered in 1936, and Pittsburgh Railways ultimately purchased 666 Presidents' Conference Committee cars. When Johnstown purchased its cars in 1947, Pittsburgh Railways provided the operator instruction. The design was built for 48 years spreading from the United States to Western Europe and later to Eastern European systems. In the United States in 2006, Presidents' Conference Committee cars are used in San Francisco, Philadelphia, Boston, and Kenosha. (James E. Parks photograph.)

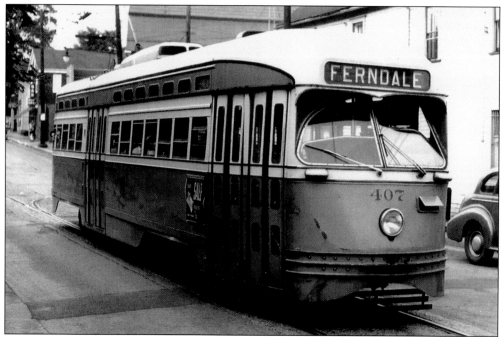

Presidents' Conference Committee car No. 407 is on the Morrellville line at Strayer Street just south of Chandler Avenue. On May 18, 1953, at 5:30 a.m. car No. 406 was damaged beyond repair when it was hit and shoved 235 feet into a V by a Conemaugh and Black Lick Railroad train at the Atwood Street crossing. Seven passengers were injured. The car was not replaced. (Harold Jenkins photograph.)

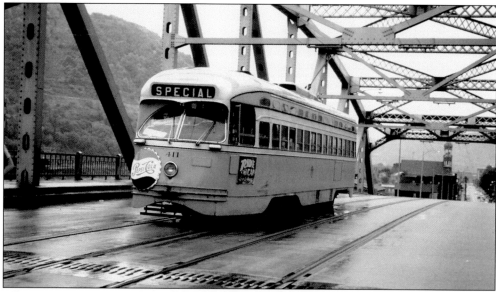

Johnstown Traction Company car No. 411 was outbound on the Maple Avenue bridge on the Franklin line with a clear view of the expansion joint for both the bridge and track. The last major track replacement was made on the Maple Avenue bridge when it was closed for reconstruction from 1956 to 1958. The rails were set in strips of temporary asphalt to facilitate track removal. (Kenneth C. Springirth photograph.)

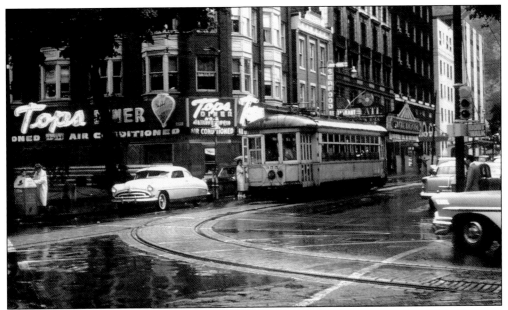

In the late afternoon rain of October 27, 1959, car No. 355 is heading eastward on Main Street at Market Street in downtown Johnstown. The January 21, 1916, *Johnstown Tribune* newspaper had a story about trolley No. 76 catching fire at Roxbury Loop, and the crew had the passengers leave the car, and in record time they motored the car to the fire house to get the fire extinguished. (Kenneth C. Springirth photograph.)

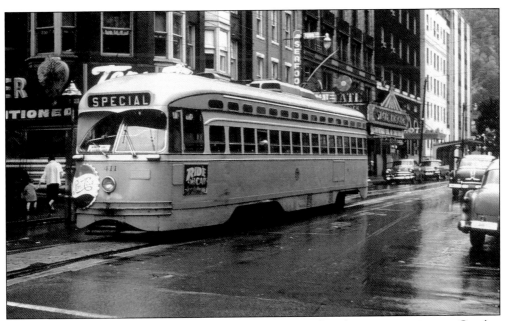

Presidents' Conference Committee car No. 411 is on a rail enthusiast excursion on October 27, 1959, heading eastward on Main Street at Market Street. All electric cars 401 to 417 had St. Louis B3 trucks and were delivered during January and February 1947. They were first placed in service on the Roxbury-Morrellville line. (Kenneth C. Springirth photograph.)

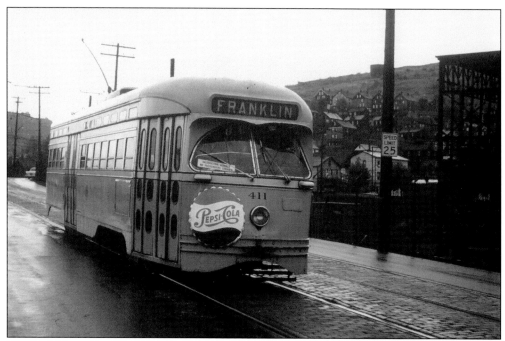

The Bethlehem Steel Franklin Plant provided the setting for Presidents' Conference Committee car No. 411 on the Franklin line on October 27, 1959. During shift changes, the Franklin line was busy transporting workers to and from the steel mills, but industrial cutbacks along with increased automobile usage drastically reduced ridership. (Kenneth C. Springirth photograph.)

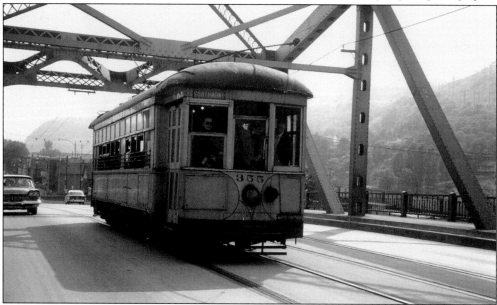

Car No. 355 was on the Maple Avenue bridge over the Little Conemaugh River and the railroad serving the Bethlehem Steel Franklin Works on June 11, 1960. An earlier Maple Avenue bridge collapsed on March 21, 1916, under the weight of six trolleys and about 600 passengers. The cars did not turn over and were wedged into the shape of a broad V. Fortunately there were no fatalities. (Kenneth C. Springirth photograph.)

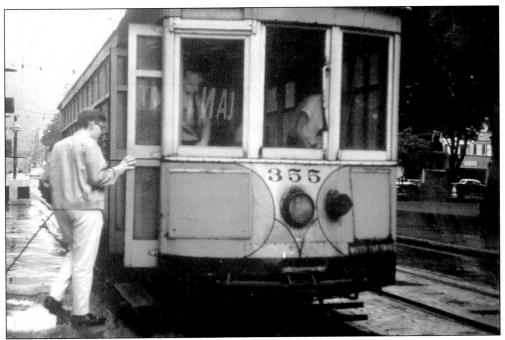

The switch has been set for car No. 355 to make a right turn from Main Street to Franklin Street on May 30, 1960. This 1926 double truck St. Louis Car Company product was originally a single end car but was later modified into a double end car. (Kenneth C. Springirth photograph.)

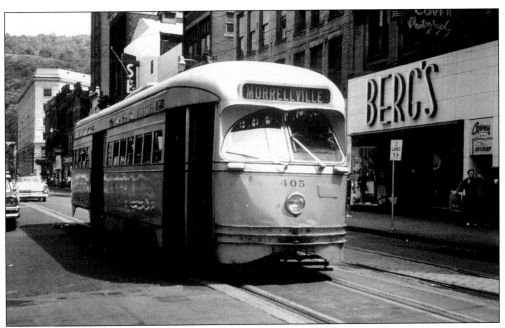

Main Street between Clinton and Franklin Streets is the setting for Johnstown Traction Company Presidents' Conference Committee car No. 405 on June 11, 1960. This 50 passenger car had been in service in Johnstown for 13 years. While the car would be scrapped, its motors, trucks, and electrical components would be used in Brussels trolleys. (Kenneth C. Springirth photograph.)

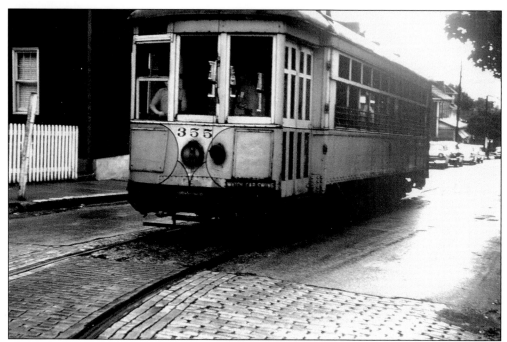

With less than a month to go Johnstown Traction Company car No. 355 is on Chandler Avenue ready to turn onto Strayer Street in Morrellville on May 30, 1960. From downtown Johnstown, Morrellville cars used Washington Street, Roosevelt Boulevard, Broad Street, and made a wide loop in Morrellville via Fairfield Avenue, Strayer Street, and Chandler Avenue. (Kenneth C. Springirth photograph.)

The disconnected track for the Oakhurst shuttle can be seen off to the left of trolley No. 355 on Chandler Avenue as it prepares to make the turn onto Strayer Street in Morrellville on May 30, 1960. When regular trolley service to Oakhurst ended in 1953, the first morning trip to Morrellville made one franchise run to Oakhurst until 1958. (Kenneth C. Springirth photograph.)

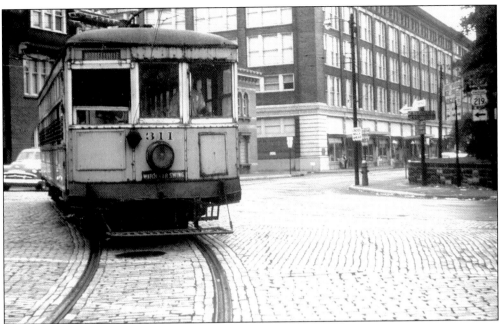

Johnstown Traction Company car No. 311 on Washington Street, just past Walnut Street, in downtown Johnstown on May 30, 1960. Washington, Walnut, Main, and Market Streets formed the main loop in downtown Johnstown that provided access to each trolley line. In less than two weeks the trolleys would be gone, and there would be new one-way, downtown street traffic patterns. (Kenneth C. Springirth photograph.)

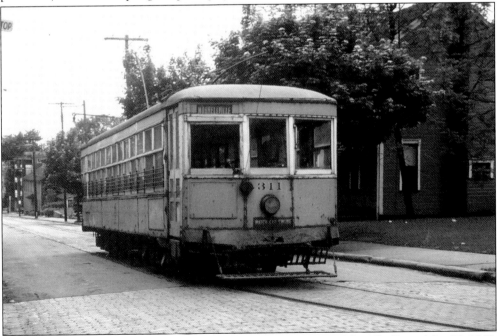

Ex-Bangor, Maine, Birney car No. 311 is on Chandler Avenue in Morrellville on May 30, 1960. This car was a favorite to rail enthusiasts, and people came from all over the country to photograph Johnstown trolley cars and trackless trolleys. (Kenneth C. Springirth photograph.)

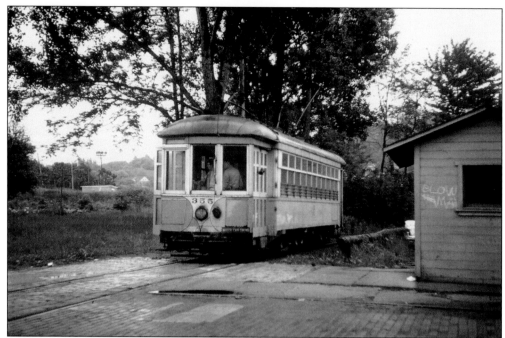

Johnstown Traction Company car No. 355 is on the exit track at Roxbury Loop ready to head back to downtown Johnstown on May 30, 1960. This car had been in service in Johnstown for about 34 years, and it was still a very reliable well running car. (Kenneth C. Springirth photograph.)

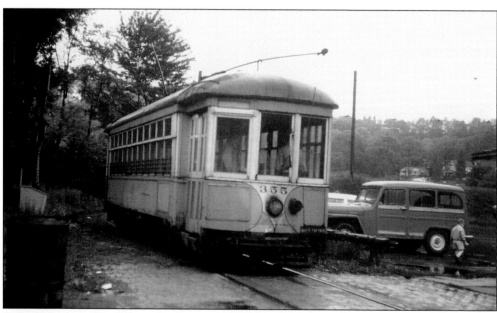

St. Louis built car No. 355 is at Roxbury Loop on May 30, 1960, heading for downtown Johnstown. Luna Park was once at Roxbury Loop. This amusement park was not established by the trolley company, but the park did generate more riding for the trolley system. Until the widespread use of the automobile, people rode trolleys to work, school, recreation, and just for the fun of it. (Kenneth C. Springirth photograph.)

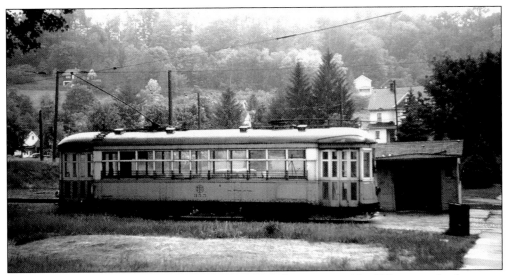

The sylvan Roxbury Loop finds Johnstown Traction Company car No. 355 waiting for departure time for the trip to downtown Johnstown on May 30, 1960. Seating 44, this car weighed 19.4 tons was 41 feet 5 inches long, 7 feet wide, 11 feet 4 inches high, and had been in service in Johnstown since 1926. (Kenneth C. Springirth photograph.)

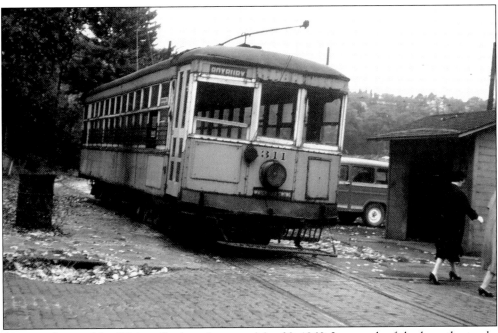

Birney safety car No. 311 is at Roxbury Loop on May 30, 1960. Just north of the loop the tracks were in a medium strip in the road right-of-way. It is hard to imagine that this was once the site of Luna Park, an amusement area that had a roller coaster and a racetrack around a lake, which was used for boating. (Kenneth C. Springirth photograph.)

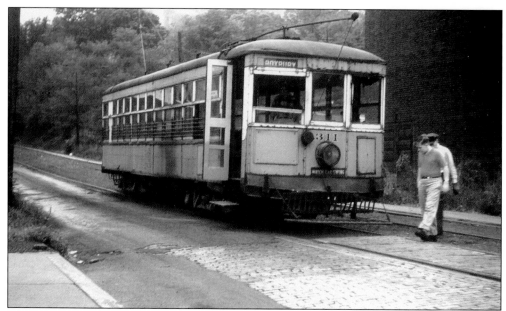

Johnstown Traction Company car No. 311 was on the median strip of Roxbury Avenue at Southmont Boulevard on May 30, 1960, with the Roxy Theatre building on the right. The end of the line at Roxbury Park was a short distance south of this point. Roxbury cars were through routed to Morrellville. (Kenneth C. Springirth photograph.)

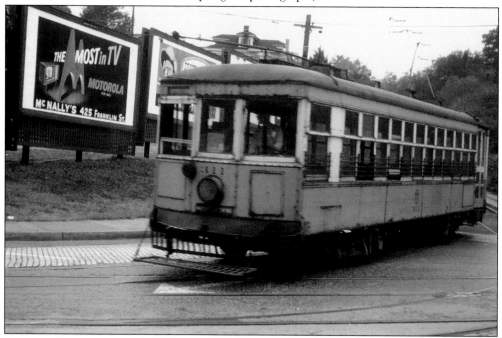

Car No. 311 is turning from Roxbury Avenue to Southmont Boulevard on May 30, 1960. Tracks going to the right in the lower part of the picture were used by Southmont cars until the line was converted to bus operation in 1954. When trolley service ended on June 11, 1960, the Roxbury line was temporarily a bus line until the overhead wires were completed for trackless trolley operation. (Kenneth C. Springirth photograph.)

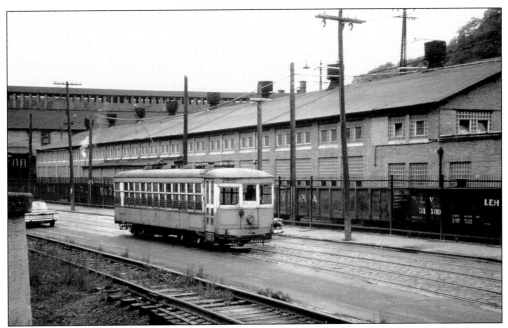

Johnstown Traction Company car No. 311 is on the Franklin line on Center Street (now known as Clinton Street) with the Pennsylvania Railroad tracks in the background on May 30, 1960. Johnstown Traction Company deserves credit for making their historic trolleys available for charter at a fair price. (Kenneth C. Springirth photograph.)

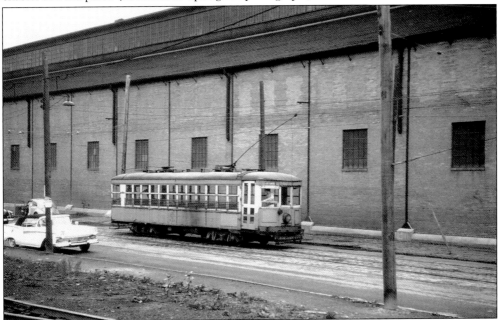

Car No. 311 is on Center Avenue (now known as Clinton Street), with the Gautier Works in the background, heading to downtown Johnstown via the Franklin line on May 30, 1960. Because trolleys lasted to 1960 in Johnstown, trolley museums throughout the United States had a chance to obtain many vintage trolleys that otherwise would have been lost. (Kenneth C. Springirth photograph.)

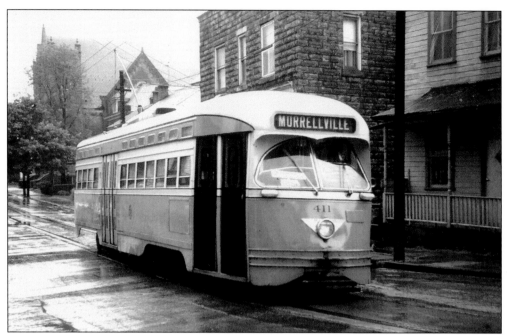

Presidents' Conference Committee trolley No. 411 was at Chandler Avenue near Leslie Street at the bottom of Chandler Avenue hill on May 30, 1960. This was one of 17 cars built by St. Louis Car Company for Johnstown Traction Company each costing about $22,000. With leather covered seating for 50 passengers, there were 18 double seats, 10 single seats, and a large seat for four in the rear. (Kenneth C. Springirth photograph.)

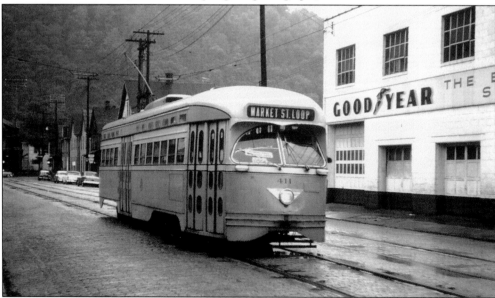

On a rainy May 30, 1960, Johnstown Traction Company car No. 411 is on Washington Street at Walnut Street in downtown Johnstown inbound from Morrellville. This Presidents' Conference Committee car had a length of 46 feet 5.375 inches, and weight without passengers was 33,500 pounds. The paint scheme was orange and cream with a gray roof and black trim. (Kenneth C. Springirth photograph.)

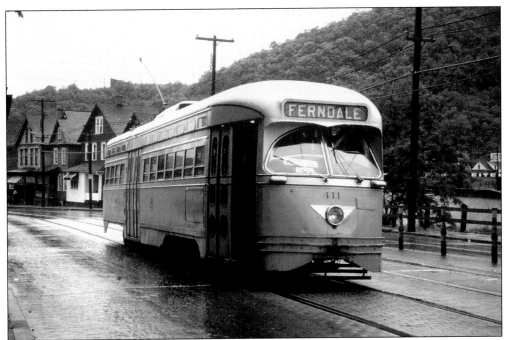

Johnstown Traction Company car No. 411 is outbound on Franklin Street at the Hickory Street bridge on May 30, 1960. The Presidents' Conference Committee design of this car featured a sharply tipped windshield to reduce glare for the operator. Each passenger window had a hand crank for opening and closing the window to enhance passenger comfort. (Kenneth C. Springirth photograph.)

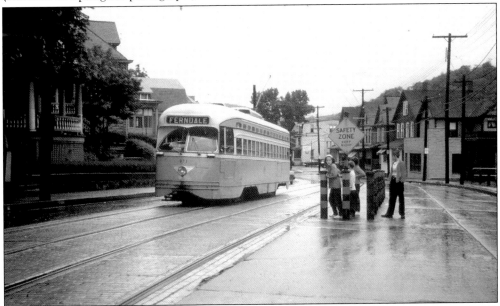

A group of schoolchildren were at the safety zone as Presidents' Conference Committee car No. 411 is heading south on Franklin Street at the Hickory Street bridge on May 30, 1960. On this type of car the operator had his own seat and controlled car operation by a series of switches and floor pedals. (Kenneth C. Springirth photograph.)

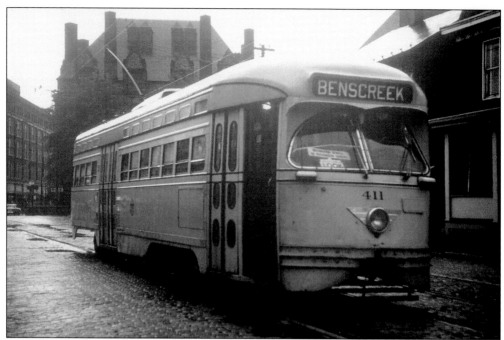

Under intermittent rain showers, Presidents' Conference Committee car No. 411 is on Washington Street near Walnut Street on May 30, 1960. In 1929, a group of railway executives met in Chicago and organized the Presidents' Conference Committee, which appropriated money and hired engineers to design, build, and test a trolley that would have good passenger appeal with good performance at a reasonable cost to compete with the automobile. (Kenneth C. Springirth photograph.)

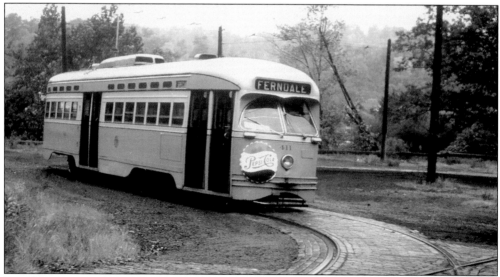

Ferndale Loop was the southern point for Presidents' Conference Committee car No. 411 on May 30, 1960. Trackage was out of service south of this loop for Benscreek, and the line originally went to Windber. Initially this style of car did attract riders, but as automobile usage continued to increase and cutbacks occurred at the steel mills in Johnstown, ridership decreased. (Kenneth C. Springirth photograph.)

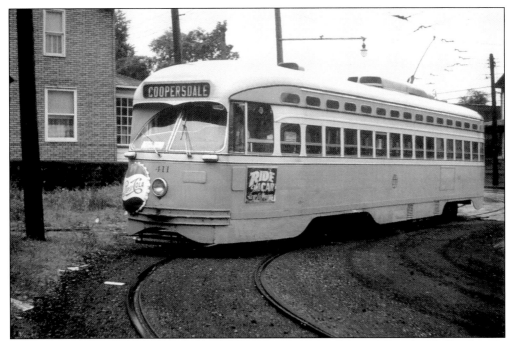

"Ride this car" to keep it running was the sign near the front of Presidents' Conference Committee car No. 411 as it pauses at the Coopersdale Loop in June 1959. Increasing use of the automobile plus strikes at the steel mills resulted in ridership declines. Johnstown Traction Company was trying to make the public aware of the importance of using the transit service. (Kenneth C. Springirth photograph.)

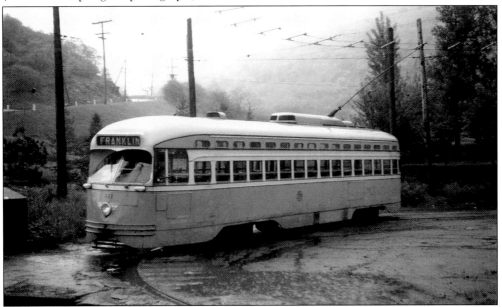

It is a rainy day on May 30, 1960, that found Johnstown Traction Company Presidents' Conference Committee car No. 411 with its temporary front silver wings negotiating Franklin Loop. The trackless trolley wire was already in place for the up coming conversion from trolley car operation. (Kenneth C. Springirth photograph.)

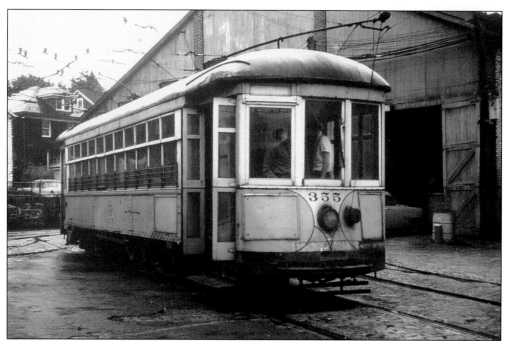

Johnstown Traction Company car No. 355 is ready to head out of Moxham Car Barn for a rail enthusiast excursion on May 30, 1960. The trolley car operators were very accommodating in allowing requests for photograph stops on these trips, because with the end of service rapidly coming, many were anxious to get as many pictures of the cars as possible. (Kenneth C. Springirth photograph.)

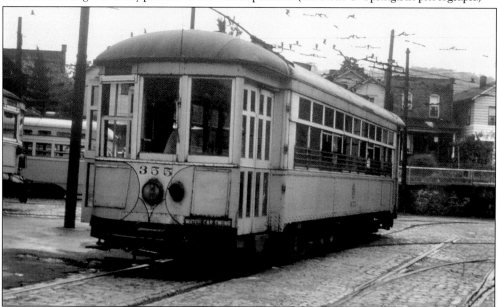

Car No. 355 is at Moxham Car Barn on May 30, 1960, with Birney No. 311 and Presidents' Conference Committee car No. 411 on the left. All three of these cars represented different time periods. There may never be another company like Johnstown Traction Company in allowing these cars to be available in such a cooperative and customer oriented manner. (Kenneth C. Springirth photograph.)

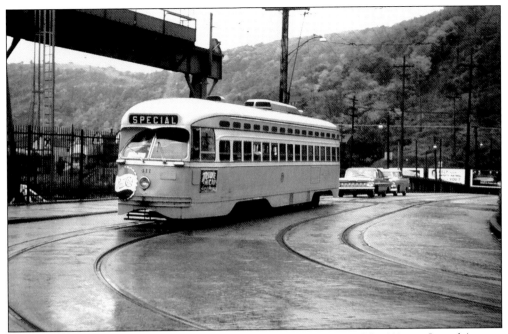

Johnstown Traction Company Presidents' Conference Committee car No. 411 is on Laurel Avenue ready to turn onto Broad Street on the Coopersdale line heading into downtown Johnstown on May 30, 1960. This was the best running car of its class. On all-day excursions in 1960, cars 311, 355, and 411 were often used. (Kenneth C. Springirth photograph.)

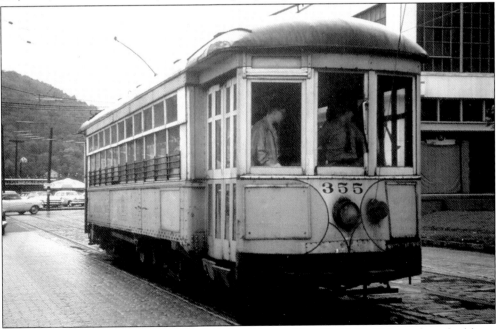

Car No. 355 is at Central Avenue and Valley Pike on May 30, 1960. This trackage had been used by Ferndale cars until November 25, 1959, when the Ferndale line was converted to bus operation. This trackage remained as barn access trackage for Morrellville, Roxbury, and Franklin cars. (Kenneth C. Springirth photograph.)

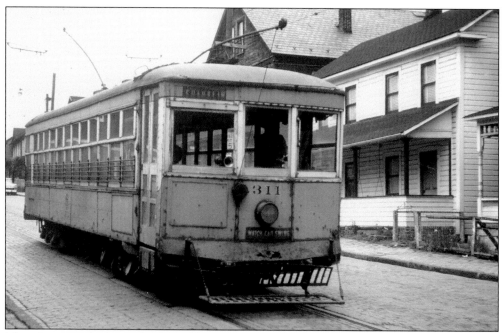

Main Street in the borough of Franklin provided the setting for Johnstown Traction Company car No. 311 on May 30, 1960. The overhead wires are already in place for the conversion to trackless trolley operation. This unsignalled short section of single track was near the end of the line at Franklin Loop. (Kenneth C. Springirth photograph.)

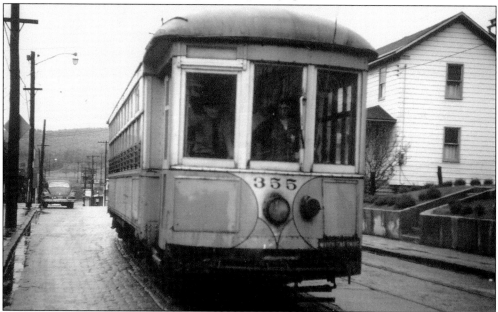

Car No. 355 has just left Franklin Loop and is heading south on Main Street on May 30, 1960. This was the last small city trolley operation in the United States. Students of transportation came from all over to photograph and ride the system. Rail clubs and individuals chartered cars, because in 1960, nothing compared with the variety of trolleys at Johnstown. (Kenneth C. Springirth photograph.)

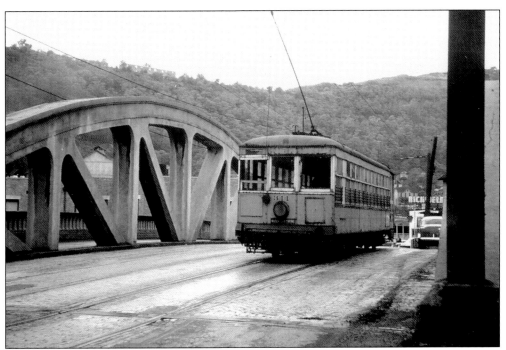

Atwood Street bridge over Little Conemaugh River provided the location for Johnstown Traction Company car No. 311 heading to downtown Johnstown on May 30, 1960, on the Franklin line. This car was designed as a one operator car that saved labor costs, because no conductor was required. (Kenneth C. Springirth photograph.)

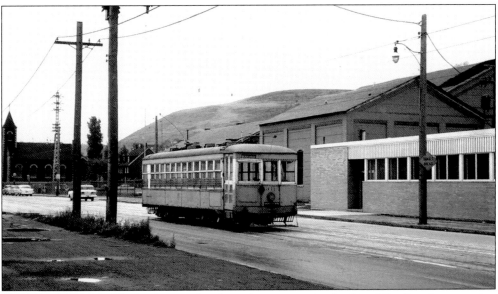

Car No. 311 is on Maple Avenue heading downtown on the Franklin line in a section known as Woodvale on May 30, 1960. This car was 38 years old in 1960. As of 2006, the car has reached its 84th birthday, with the last 46 years at Rockhill Trolley Museum. (Kenneth C. Springirth photograph.)

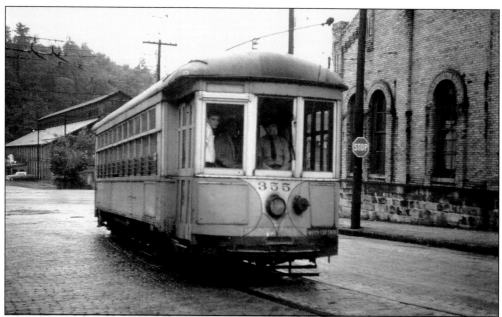

Johnstown Traction Company car No. 355 has just turned off Central Avenue onto Bond Street to loop into the Moxham Car Barn on May 30, 1960. The trolley weighed 38,000 pounds and had type K-35KK controls. Horner Street trolleys before conversion to trackless trolley operation used this trackage as its southern terminus. (Kenneth C. Springirth photograph.)

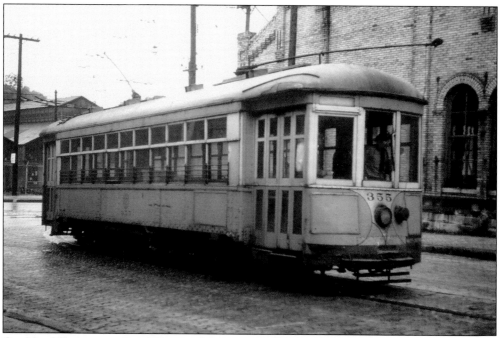

Car No. 355 poses on Bond Street after turning off Central Avenue on May 30, 1960, with the Moxham Car Barn in the background. In 2006, this building was still used as a bus garage by the Cambria County Transit Authority. The double truck trolley was equipped with four Westinghouse model WH-510A2 motors. (Kenneth C. Springirth photograph.)

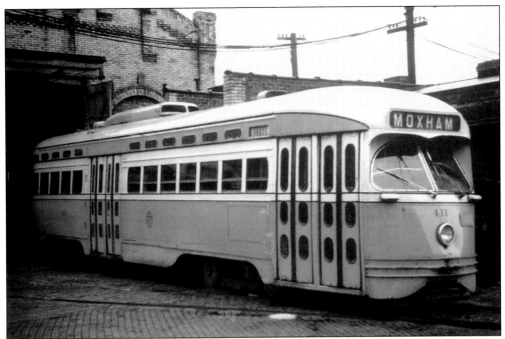

Johnstown Traction Company car No. 411 is at Moxham Car Barn on May 30, 1960. This car was made from modern materials, was economical to build, was practical to maintain, was comfortable to ride, and utilized a design that large cities like Pittsburgh and small cities like Johnstown could use. (Kenneth C. Springirth photograph.)

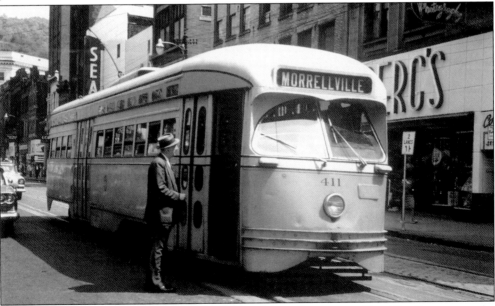

Johnstown Traction Company car No. 411 on Main Street near Franklin Street was the last regular service car to operate in Johnstown on Saturday June 11, 1960. This Presidents' Conference Committee car represented a postwar design that was used in a number of United States cities. The last cars of this type were built for Toronto in 1951 and San Francisco in 1952. (Kenneth C. Springirth photograph.)

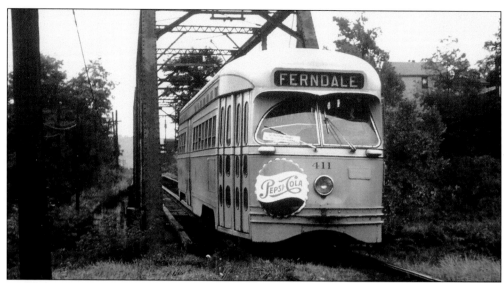

Presidents' Conference Committee car No. 411 is southbound on the Stonycreek River bridge heading for Ferndale in June 1959. The sleek modern style of this car with its inclined windshield and standee windows had its start in a 1936 design whose research was unprecedented in the transit industry. (Kenneth C. Springirth photograph.)

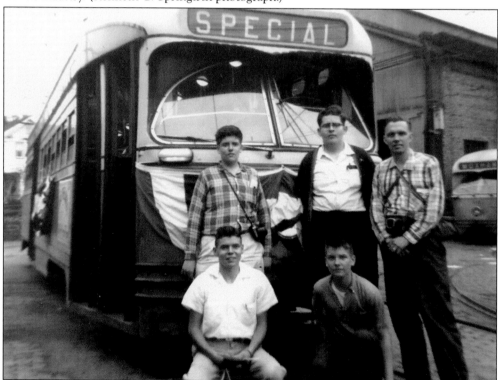

At Moxham Car Barn on Saturday, June 11, 1960, five students of transportation, who had spent the night traveling from Philadelphia to Johnstown to make the last ride, pose in front of a decorated trolley. From left to right are (first row) Ken Springirth and John Gbur; (second row) Tom Ratigan, Henry Adamcik, and Jim Kelly.

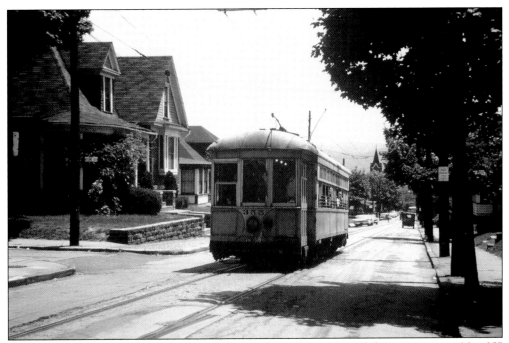

Saturday, June 11, 1960, was the last day of trolley car service in Johnstown as car No. 355 headed west on Chandler Avenue at Stone Street in Morrellville with the derail noted just ahead of the trolley. Johnstown Traction Company made a significant contribution to the education of future generations that can see Johnstown trolleys in a number of trolley museums. (Kenneth C. Springirth photograph.)

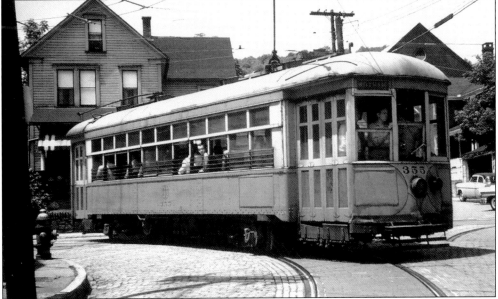

Car No. 355 has just turned from Chandler Avenue onto Strayer Street on June 11, 1960. The Johnstown Traction Company's decision to keep the trolleys in service up to 1960 meant a lot of "youngsters" and future generations would be able to view many of the Johnstown trolleys in museums. (Kenneth C. Springirth photograph.)

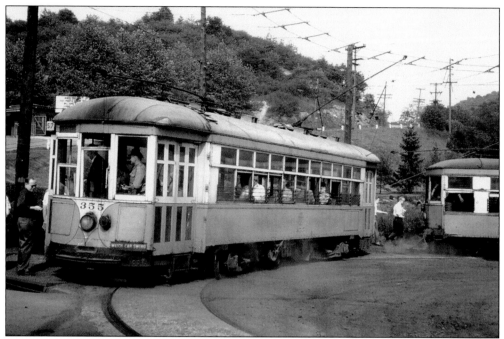

Car No. 355 followed by No. 311 is at Franklin Loop on the last day of trolley car operation in Johnstown on June 11, 1960. Johnstown's trolley loops were great places to take pictures of trolleys, and rail enthusiasts flocked here to record this event for transportation history, plus say farewell to an amazing trolley system. (Kenneth C. Springirth photograph.)

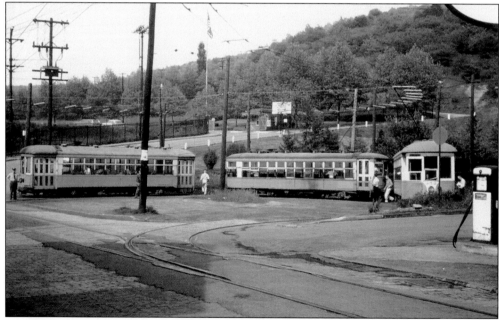

Franklin Loop was busy on the last day of trolley car operation on June 11, 1960, with three cars Nos. 355, 311, and 352 parked for pictures. This is Main Street north of Bon Air Street. This represented a scene that cannot be duplicated, as car No. 352 was lost in a fire on September 28, 2003, at the National Capital Trolley Museum. (Kenneth C. Springirth photograph.)

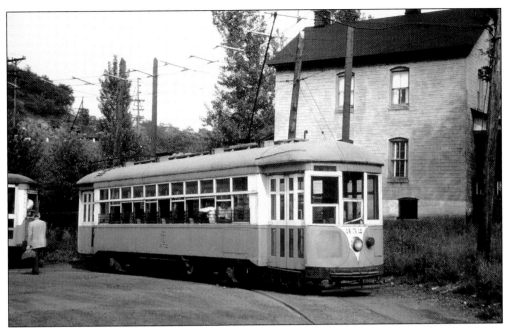

Car No. 352 is behind car No. 311 at Franklin Loop on June 11, 1960, posing for pictures on this last day of trolley service. The Franklin line was entirely street running, and in 1960, the line was still busy during the change of shifts at the steel mills located along the route. (Kenneth C. Springirth photograph.)

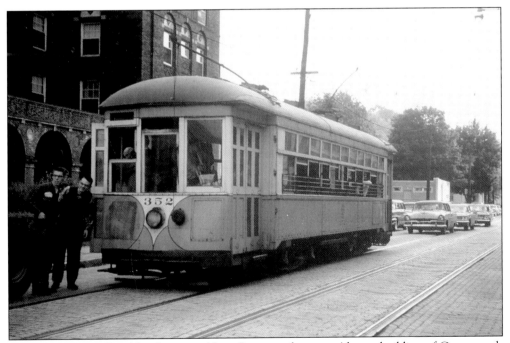

Car No. 352 is on Franklin Street at Akers Street at the nurses' home building of Conemaugh Valley Memorial Hospital on the last day of trolley car operation June 11, 1960. Clara Barton founded the hospital after the 1889 flood. (Kenneth C. Springirth photograph.)

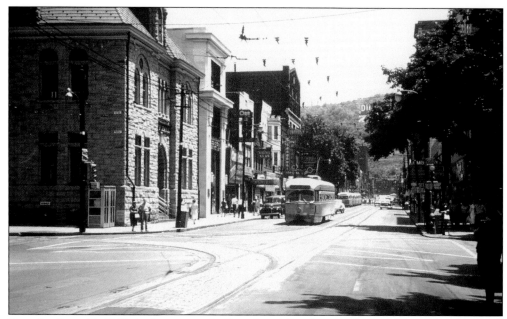

Saturday June 11, 1960, is the scene of a Presidents' Conference Committee car heading west on Main Street at Market Street with the Johnstown City Hall shown on the left. Buses in the rear were at Central Park, which was a departure point for interurban bus routes to South Fork, Nanty Glo, and Ebensburg that replaced the former Southern Cambria Railway. (Kenneth C. Springirth photograph.)

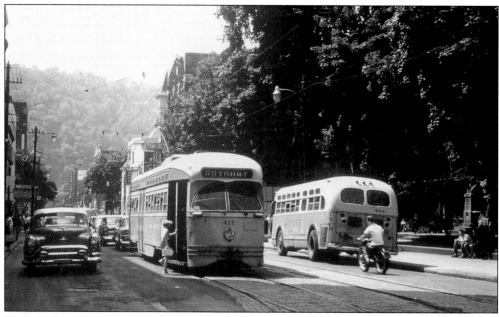

Roxbury bound car, Presidents' Conference Committee car No. 417, stops for a passenger on Main Street at Franklin Street on Saturday afternoon June 11, 1960, with just a few hours remaining of trolley car operation. The car, when it was placed in service in 1947, created a desire to ride it, and with 13 years of usage, it was still a streamlined beauty. (Kenneth C. Springirth photograph.)

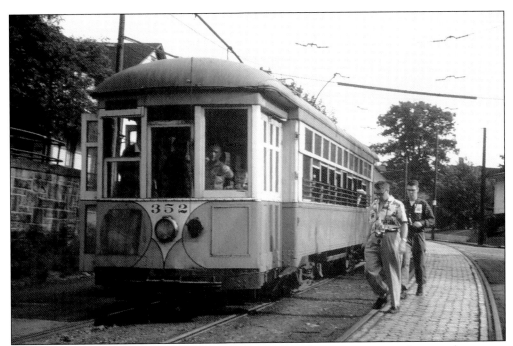

Car No. 352, a classic city car built by St. Louis Car Company, is at a photograph stop on Roxbury Avenue one block north of the Roxbury Loop on June 11, 1960. The stone retaining wall, which was still in place in 2006, was for the Roxbury Grade School, which in 2006 was vacant. (Kenneth C. Springirth photograph.)

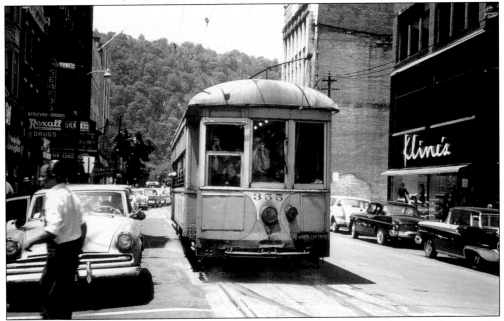

Car No. 355 is at Main Street and Market Street at the switch for the Market Street loop on the last day of trolley car operation on June 11, 1960. Kline's women's apparel store is no longer in business. Today a sandwich shop occupies that spot. The vacant lot left of Kline's was the site of the Cambria Theatre that had been demolished. (Kenneth C. Springirth photograph.)

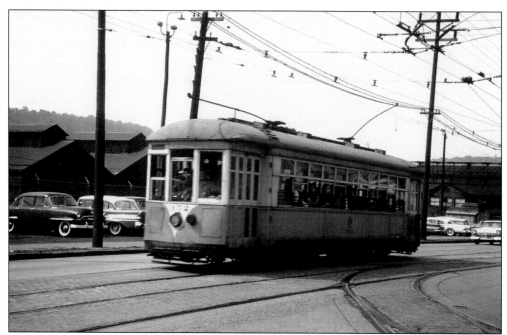

Central Avenue in Moxham provided the setting for car No. 352 heading back to Moxham Car Barn on the final day of trolley car operation on June 11, 1960. The bottom right of the picture shows the exit track used by Horner Street cars when they left the Moxham Car Barn. (Kenneth C. Springirth photograph.)

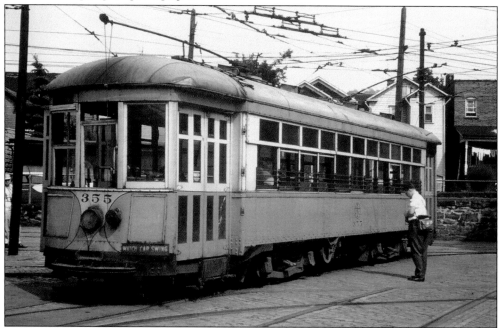

Car No. 355 was on the exit track at Moxham Car Barn on June 11, 1960. During the workweek, trippers used this track leaving the carbarn 30 to 60 minutes before the 3:00 p.m. shift change at the steel mills. Transit ridership in Johnstown declined dramatically as industrial employment levels declined and automobile ownership increased. (Kenneth C. Springirth photograph.)

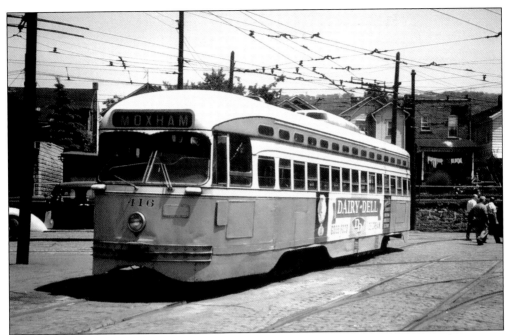

A look at Moxham Car Barn finds Presidents' Conference Committee car No. 416 posing in the afternoon sun of June 11, 1960. In North America, there were 4,978 Presidents' Conference Committee cars built with the first of this type built in 1936. Johnstown purchased 17 in 1947, and the last cars of this type were built in 1952. (Kenneth C. Springirth photograph.)

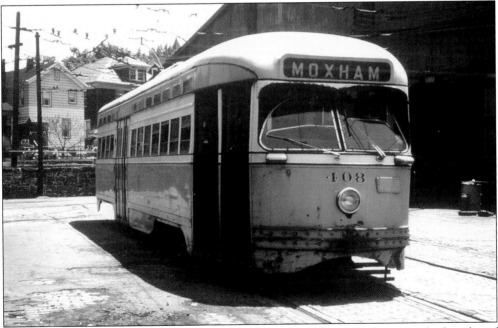

Presidents' Conference Committee car No. 408 was at Moxham Car Barn on the last day of trolley car operation: June 11, 1960. This type of car surpassed its predecessors in acceleration, braking, and passenger comfort. However, the trolley could not halt the severe ridership decline, as fewer workers were needed at the steel mils. (Kenneth C. Springirth photograph.)

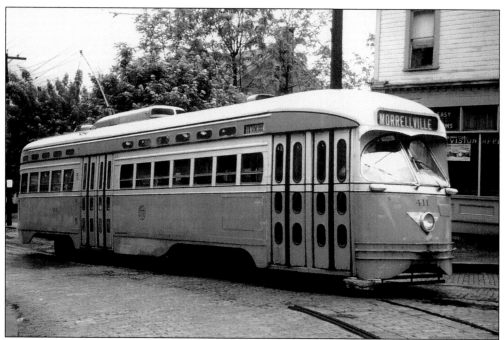

Presidents' Conference Committee car No. 411, sporting temporary silver wings on the front for a rail enthusiast excursion, is on Chandler Avenue ready to turn onto Strayer Street on May 30, 1960. The disconnected track for the Oakhurst shuttle still shows in the brick street. (Kenneth C. Springirth photograph.)

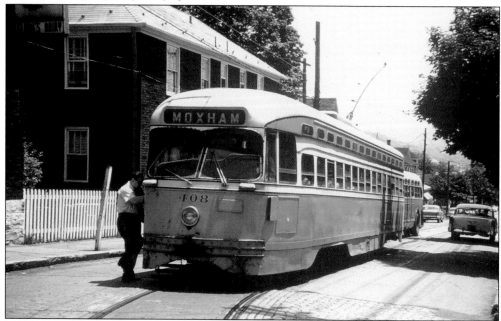

On the afternoon of June 11, 1960, Presidents' Conference Committee car No. 408 picks up a passenger at Chandler Avenue and Strayer Street. The bus behind the trolley is the Oakhurst bus. Regular trolley service to Oakhurst ended in 1953 but a franchise run was made until 1958. (Kenneth C. Springirth photograph.)

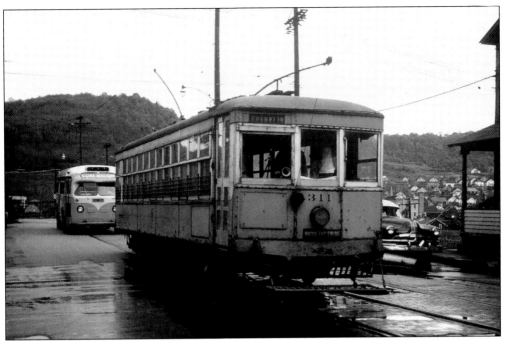

On May 30, 1960, Johnstown Traction Company car No. 311 has just turned from River Avenue to Locust Street and is about to turn left onto Main Street in Franklin borough. The Conemaugh bus is behind the trolley. The car floor on the bottom was 5/8 inch clear spruce covered by 3/4 inch hard maple. Interior finish was cherry. (Kenneth C. Springirth photograph.)

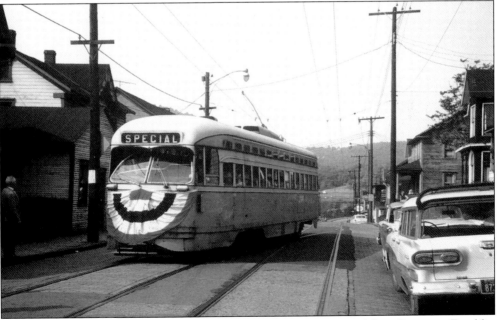

A decorated last run Presidents' Conference Committee car is on Main Street in Franklin borough just south of the Franklin Loop on June 11, 1960. In 2006, Presidents' Conference Committee cars can be found in San Francisco, Philadelphia, Boston, and Kenosha. (Kenneth C. Springirth photograph.)

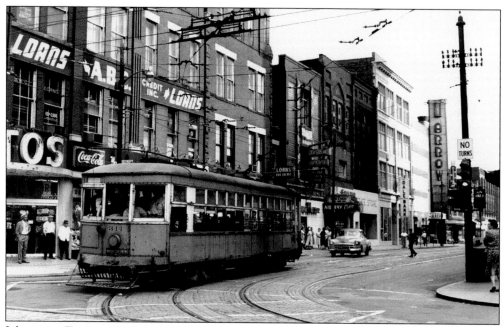

Johnstown Traction Company Birney safety car No. 311 is turning from Franklin Street onto Main Street on June 11, 1960, in downtown Johnstown. The trolley was originally built as No. 14 for the Bangor Railway and Electric Company of Bangor, Maine, and was filled with rail enthusiasts for its last day of service in Johnstown. (Cover Studio Photography.)

```
                        FRANKLIN
                    Monday thru Friday

Main & Market   a.m.  555 - 610 - 615 - 625 - 635 - 640 - 655 - 740 - 805 - 850 -
to Franklin           1000 -1110.
                p.m.  1215 - 130 - 205 - 245 - 325 - 405 - 440 - 515.

Franklin to     a.m.  610 - 625 - 640 - 645 - 710 - 755 - 825 - 905 -1015 -1125.
City Hall Corner p.m. 1235 - 150 - 230 - 310 - 345 - 425 - 500 - 535.

Franklin to     a.m.  610 - 625 - 645 - 710 - 755 - 825 - 905 -1015 -1125.
Coopersdale     p.m.  1235 - 150 - 230 - 310 - 345 - 425 - 500.

Coopersdale     a.m.  540 - 610 - 640 - 720 - 750 - 830 - 940 -1050 and 1200 Noon.
to Franklin     p.m.  110 - 150 - 230 - 305 - 350 - 425 - 500.

           For other schedule information, or Charter Bus
           Rates for Group or Party Service, phone 7-4638.

                        SATURDAY

Main & Market   a.m.  555 - 605 - 610 - 625 - 655 - 725 - 805 - 850 -1000 -1110.
to Franklin     p.m.  1215 - 130 - 205 - 230 - 245 - 325 - 405 - 435 - 515.

Franklin to     a.m.  610 - 625 - 715 - 755 - 820 - 905 -1015 -1125.
City Hall Corner p.m. 1235 - 150 - 310 - 345 - 425 - 500 - 535.

Franklin to     a.m.  610 - 625 - 715 - 755 - 905 -1015 -1125.
Coopersdale     p.m.  1235 - 150 - 310 - 345 - 425 - 500.

Coopersdale     a.m.  540 - 610 - 640 - 750 - 830 - 940 -1050 -1200 Noon.
to Franklin     p.m.  110 - 150 - 230 - 350 - 420 - 500.

JOHNSTOWN TRACTION COMPANY                         Effective 5-25-59
```

The Monday to Friday, May 25, 1959, Franklin schedule showed early morning peak service ranged from 5 to 15 minutes apart and midday service was about every 75 minutes from Main and Market Streets to the borough of Franklin. On Saturdays there were 19 trips from Main and Market Streets to the borough of Franklin and 13 through trips from the borough of Franklin to the Coopersdale section of Johnstown.

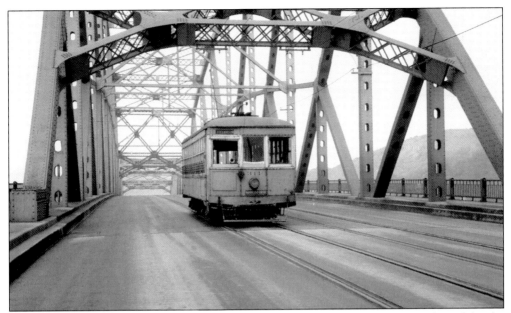

Johnstown Traction Company car No. 311 crossed the Maple Avenue bridge outbound for the borough of Franklin on May 30, 1960. As built by Wason for the Bangor Railway and Electric Company, car length over bumpers was 40 foot 3 inches, over all width 8 foot 2.875 inches, weight of car body with airbrake and control equipment 15,110 pounds, weight of trucks 9,100 pounds, and motor weight 4,450 pounds. (Kenneth C. Springirth photograph.)

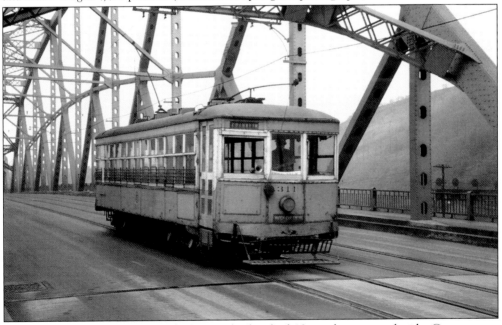

Car No. 311, shown on the Maple Avenue bridge, had 13 windows on each side. Corner posts were pressed steel. The side sheets were 3/32 inch rolled steel in four sections. The vestibule top plates, hood rim, hood carlines, posts, and ribs were of white ash. The platform floor was 7/8 inch hard maple. The roof was a plain arch type having half inch grooved poplar planking. (Kenneth C. Springirth photograph.)

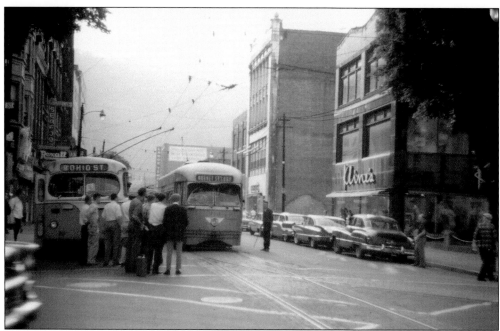

Johnstown Traction Company Presidents' Conference Committee car No. 413 is on a private excursion at Main and Market Streets on June 11, 1960. The special wings were added around the car's front headlight to commemorate the last day of trolley car operation. Trackless trolley No. 731 on the left is also on a special excursion with a Dayton, Ohio, destination sign. (Kenneth C. Springirth photograph.)

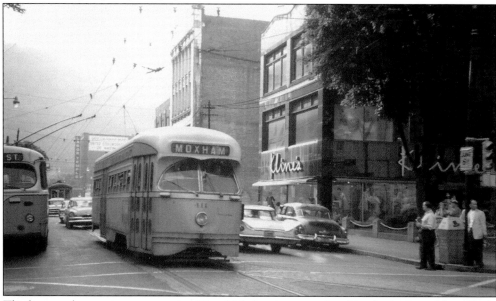

The last regular service car was No. 411, which has just completed its final trip to Morrellville on June 11, 1960, shortly after 6:00 p.m. and is heading east on Main Street about to cross Market Street for its last run to Moxham Car Barn. Residents and rail enthusiasts from around the country could be seen taking pictures of the trolleys throughout the day. (Kenneth C. Springirth photograph.)

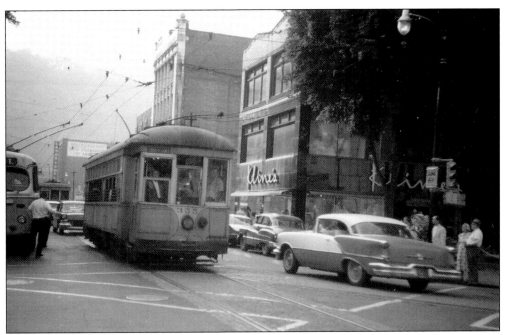

Filled to capacity, this 1926 vintage St. Louis built double end conventional Johnstown Traction Company trolley No. 355 is the first car of a Pittsburgh Electric Railway Club excursion followed by trolley No. 311 at Main and Market Streets in downtown Johnstown for the June 11, 1960, final day of service. (Kenneth C. Springirth photograph.)

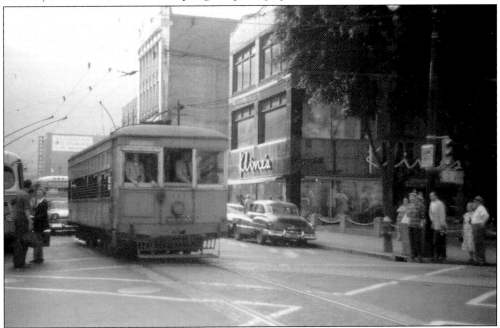

Double truck Birney car No. 311 is the second car of the three car Pittsburgh Electric Railway Club excursion passing by Main and Market Streets in Johnstown on June 11, 1960. The bus in the rear of the trolley is one of the first runs to replace trolleys going out of service. (Kenneth C. Springirth photograph.)

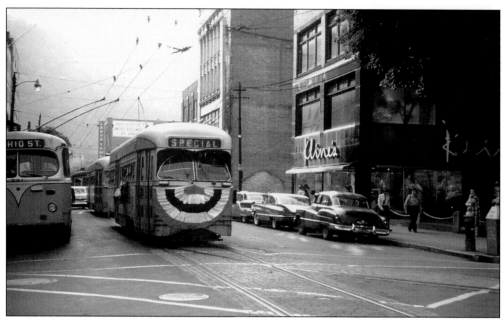

Saturday, June 11, 1960, two St. Louis Car Company (1946 vintage) Presidents' Conference Committee cars in a parade of trolleys pause at Main and Market Streets for the last run in Johnstown. On the left is a trackless trolley (electric bus) on a special excursion. New one way traffic patterns in Johnstown were factors in the conversion of the trolley lines to trackless trolley operation. (Kenneth C. Springirth photograph.)

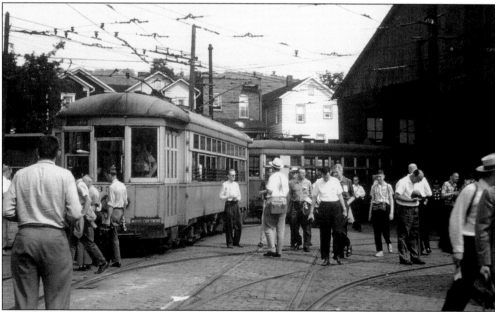

At 7:00 p.m. on June 11, 1960, the final trolley car runs entered the Johnstown Traction Company Moxham Car Barn. Wason Manufacturing Company built car No. 311 (closest to the carbarn) was followed by St. Louis Car Company built car No. 355. Over 150 trolley enthusiasts from all over the United States came to witness closure of the last small town trolley car operation in the United States. (Kenneth C. Springirth photograph.)

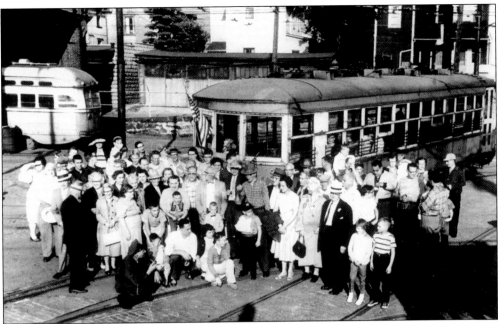

People pose in front of No. 311 on the last day of trolley operation June 11, 1960, at Moxham Car Barn. James E. Parks is sitting to the left of the boy with the arm sling in the front row of the group. Johnstown Traction Company president Warren Reitz is in the front row on the left with a dark suit, hat, and his back to the camera. (James E. Parks collection.)

```
                                  ROXBURY

                                  Saturday

Main & Market        a.m.  545 - 630 - 706 - 720 - 738 - 818 - 903 - 938 -1018 -1058 -
to Roxbury                 1138.
                     p.m.  1218 -1258 - 138 - 218 - 258 - 323 - 352 - 412 - 455 - 508 -
                            525 - 600 - 653 - 743 - 833 -1013 -1038 -1125.

Roxbury to           a.m.  545 - 600 - 635 - 702 - 735 - 742 - 812 - 847 - 927 -1007 -
City Hall Corner           1047 -1127.
                     p.m.  1207 -1247 - 127 - 207 - 233 - 322 - 352 - 420 - 447 - 510 -
                            525 - 603 - 625 - 715 - 805 - 857 - 947 -1035 -1110 -1140.

Roxbury to           a.m.  545 - 600 - 635 - 702 - 742 - 812 - 847 - 927 -1007 -1047 -
Morrellville               1127.
                     p.m.  1207 -1247 - 127 - 207 - 233 - 322 - 352 - 420 - 447 - 510 -
                            525 - 603 - 805 - 857 - 947 -1035 -1110.

Morrellville         a.m.  530 - 615 - 648 - 720 - 800 - 845 - 920 -1000 -1040 -1120 -
to Roxbury                 1200 Noon.
                     p.m.  1240 - 120 - 200 - 240 - 305 - 335 - 355 - 438 - 450 - 508 -
                            542 - 635 - 725 - 815 - 955 -1020 -1112.

                     For other schedule information, or Charter Bus
                     Rates for Group or Party Service, phone 7-4638.
```

The June 6, 1959, Saturday schedule for the Roxbury line showed 29 trips from Main and Market Streets to the Roxbury section of Johnstown and 32 trips from Roxbury to city hall corner. Service intervals varied from 13 minutes to 45 minutes apart, and Saturday evening service intervals were irregular. There were 28 round trips from the Roxbury section of Johnstown to the Morrellville section of Johnstown.

MORRELLVILLE

Monday thru Friday

City Hall Corner to Morrellville	a.m.	505 - 523 - 535 - 545 - 600 - 615 - 630 - 640 - 700 - 712 - 727 - 742 - 754 - 806 - 818 - 830 - 842 - 858 - 912 - 927 - 942 - 957 - 1012 - 1027 - 1042 - 1057 - 1112 - 1127 - 1142 - 1157.
	p.m.	1212 - 1227 - 1242 - 1257 - 112 - 127 - 142 - 157 - 212 - 227 - 235 - 240 - 257 - 310 - 320 - 326 - 338 - 350 - 402 - 412 - 420 - 432 - 442 - 452 - 502 - 512 - 525 - 540 - 555 - 618 - 642 - 708 - 758 - 822 - 912 - 938 - 1002 - 1040 - 1052 - 1125 - 1150.
Morrellville to Main & Market	a.m.	520 - 538 - 552 - 600 - 615 - 630 - 645 - 700 - 715 - 730 - 745 - 800 - 812 - 824 - 835 - 848 - 900 - 915 - 930 - 945 - 1000 - 1015 - 1030 - 1045 - 1100 - 1115 - 1130 - 1145 - 1200 Noon.
	p.m.	1215 - 1230 - 1245 - 100 - 115 - 130 - 145 - 200 - 215 - 230 - 245 - 252 - 257 - 314 - 328 - 338 - 344 - 356 - 408 - 420 - 430 - 437 - 450 - 500 - 510 - 520 - 530 - 542 - 557 - 612 - 635 - 700 - 725 - 815 - 840 - 930 - 955 - 1020 - 1057 - 1112 - 1140 - 1205 a.m.
Morrellville to Roxbury	a.m.	520 - 615 - 630 - 700 - 715 - 745 - 812 - 848 - 915 - 945 - 1015 - 1045 - 1115 - 1145.
	p.m.	1215 - 1245 - 115 - 145 - 215 - 245 - 257 - 314 - 338 - 356 - 420 - 437 - 450 - 500 - 520 - 542 - 635 - 725 - 840 - 955 - 1020 - 1112.
Roxbury to Morrellville	a.m.	545 - 600 - 657 - 739 - 803 - 827 - 857 - 927 - 957 - 1027 - 1057 - 1127 - 1157.
	p.m.	1227 - 1257 - 127 - 157 - 220 - 255 - 323 - 347 - 405 - 427 - 447 - 457 - 510 - 525 - 603 - 805 - 857 - 947 - 1035 - 1110.
Merrellville to Moxham and Ferndale	a.m.	538 - 645 - 730 - 800 - 824 - *835 - 900 - 930 - 1000 - 1030 - 1100 - 1130 - 1200 Noon.
	p.m.	1230 - 100 - 130 - 200 - 230 - 252 - 328 - 344 - 408 - 430 - 510 - 530 - *557 - 612 - 700 - 815 - 930 - *1057 - *1140 - *1205 a.m.

* Indicates to Moxham only.

Ferndale and Moxham to Morrellville	a.m.	*450 - *508 - *520 - *530 - 610 - 640 - 722 - 746 - 810 - 838 - 907 - 937 - 1007 - 1037 - 1107 - 1137.
	p.m.	1207 - 1237 - 107 - 137 - 207 - *225 - 237 - 307 - 330 - 352 - 412 - 432 - 535 - 622 - 648 - 738 - 918 - 1020 - *1135.

* Indicates from Moxham to Morrellville.

ON NIGHTS STORES ARE OPEN UNTIL 9:00 P.M., SEE STORE NIGHTS SCHEDULE.

For other schedule information, or Charter Bus Rates for Group or Party Service, phone 74-638.

JOHNSTOWN TRACTION COMPANY Effective 5-25-59

The Johnstown Traction Company May 25, 1959, schedule shows 71 round trips from downtown Johnstown to Morrellville. Peak period service varied from 10 to 15 minutes apart and midday service was every 15 minutes. From downtown, 36 of these trips continued on to Roxbury and 33 trips went to Moxham with 28 trips going further south to Ferndale, which resulted in a 30 minute midday service interval for each of these lines. At its peak the Morrellville to Moxham line had a six minute service interval during rush hours and every eight minutes off peak periods including Sundays. At its peak the Roxbury line had an eight minute service interval during rush hours and every nine minutes off peak periods including Sundays. There once was hourly all-night service on the Roxbury, Moxham, and Morrellville lines.

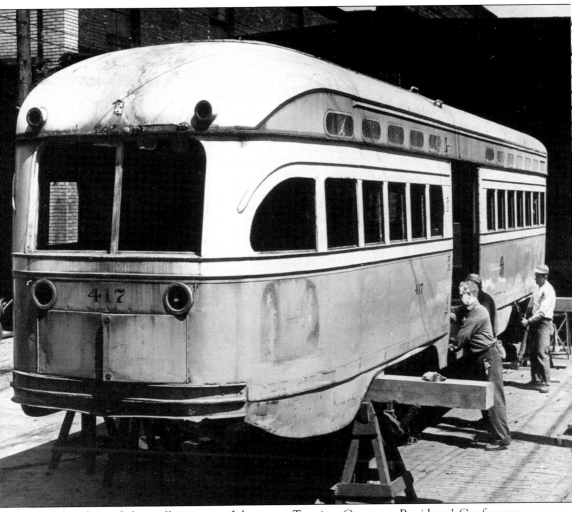

After the close of the trolley system, Johnstown Traction Company Presidents' Conference Committee trolley No. 417 was being stripped of all removable parts including motors, gears, trucks, and the electrical components. The Societe des Transports Intercommunaux de Brussels (STIB) had purchased 168 tons of parts from the 16 Johnstown Presidents' Conference Committee cars. STIB operates three metro lines, 18 trolley car lines, and 46 bus lines in Brussels, Belgium. The entire cars would have been purchased, but they were eight inches too wide for the Brussels system. These parts were used in 16 new 7000 series class Presidents' Conference Committee cars in Brussels. The Presidents' Conference Committee design continued to be used by STIB up to the 7900 series cars of 1977. The last four axle Presidents' Conference Committee cars were built for Marseille, France, in 1984. Final day of Presidents' Conference Committee car operation in The Hague, Netherlands, was May 1, 1993. (Photograph courtesy of the Tribune-Democrat, Johnstown, Pennsylvania; courtesy of James E. Parks.)

MORRELLVILLE TROLLEY COACH

Monday thru Friday

Main & Market to Morrellville

a.m. 540 – 640 – 700 – 720 – 740 – 750 – 805 – 807 – 815 – 825 – 835 – 845 – 905 – 915 – 935 – 950 –1005 –1020 – 1035 –1050 –1105 –1120 –1135 –1150.

p.m. 1205 –1220 –1235 –1250 – 105 – 120 – 135 – 150 – 205 – 220 – 235 – 250 – 305 – 315 – 335 – 350 – 400 – 408 – 415 – 420 – 435 – 445 – 455 – 505 – 515 – 525 – 540 – 550 – 610 – 640 – 705 – 730 – 755 – 820 – 845 – 910 – 935 –1000 –1025 –1050 –1115.–1135.

Washington & Franklin to Morrellville

a.m. 505 – 520 – 525 – 530 – 545 – 600 – 620 – 645 – 650 – 655 – 710 – 725 – 727 – 735 – 745 – 755 – 808 – 815 – 825 – 835 – 845 – 855 – 910 – 925 – 940 – 955 –1010 – 1025 –1040 –1055 –1110 –1125 –1140 –1155.

p.m. 1210 –1225 –1240 –1255 – 110 – 125 – 140 – 155 – 210 – 225 – 232 – 240 – 255 – 310 – 320 – 325 – 328 – 335 – 340 – 355 – 405 – 415 – 425 – 435 – 445 – 455 – 500 – 505 – 510 – 520 – 530 – 545 – 600 – 625 – 650 – 715 – 740 – 805 – 830 – 855 – 920 – 945 –1010 –1035 –1055 – 1120 –1125 –1150.

Strayer & Chandler to City

a.m. 520 – <u>535</u> – <u>540</u> – <u>550</u> – 605 – 620 – 640 – 700 – 710 – 720 – 730 – 745 – 747 – 755 – 805 – 815 – 825 – 835 – 845 – 855 – 905 – 915 – 930 – 945 –1000 –1015 –1030 – 1045 –1100 –1115 –1130 –1145 –1200.

p.m. 1215 –1230 –1245 – 100 – 115 – 130 – 145 – <u>150</u> – 200 – 215 – 230 – 245 – 252 – 300 – 315 – 330 – 340 – 345 – 348 – 355 – 400 – 415 – 425 – 435 – 445 – 455 – 505 – 515 – 520 – 525 – 530 – 540 – 550 – 605 – 620 – 645 – 710 – 735 – 800 – 825 – 850 – 915 – 940 – <u>950</u> –1005 – 1030 –1055 –1115 –1140 –1145 –1210 a.m.

UNDERLINED COACHES RUN THRU TO FRANKLIN.

ROUTE

Morrellville coaches entering downtown:

Beginning at Washington St. to Walnut St., to Main St., to Clinton St., to Washington St., to Roosevelt Boulevard.

Terminal for all Morrellville coaches will be on Washington St., between Franklin and Market Streets.

JOHNSTOWN TRACTION COMPANY Effective 6-13-60.

With abandonment of trolley car service on Saturday, June 11, 1960, trackless trolley (trolley coach) service began on the Morrellville and Franklin lines on Monday, June 13, 1960. There were 82 trips from Washington and Franklin Streets in downtown Johnstown to Morrellville. From Strayer Street and Chandler Avenue in Morrellville to the city there were 84 trips. There were six trips that went from Morrellville directly to the borough of Franklin. Morning peak service from Morrellville to Johnstown ranged from 2 to 20 minutes apart. Midday service was every 15 minutes. Evening service was every 25 minutes. On Saturdays there were 69 trips from Washington and Franklin Streets to Morrellville. From Strayer Street and Chandler Avenue in Morrellville to the city there were 71 trips. On Saturday four trips went from Morrellville directly to the borough of Franklin. Daytime Saturday service was every 15 minutes and evening service was every 25 minutes.

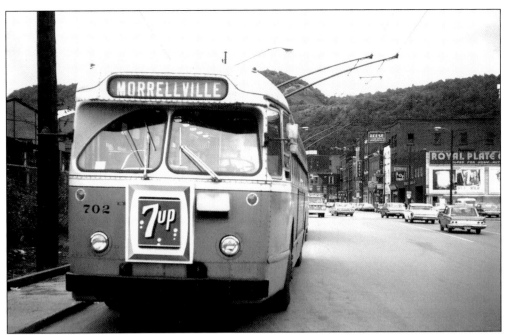

Johnstown Traction Company trackless trolley No. 702, one of six vehicles built in 1951 for the Horner Street line by St. Louis Car Company, is at a layover point on Washington Street just west of Franklin Street on August 26, 1967. A trackless trolley is an electric rubber tired transit vehicle, manually steered, and receives its power through two poles each of which contacts an overhead wire. (Kenneth C. Springirth photograph.)

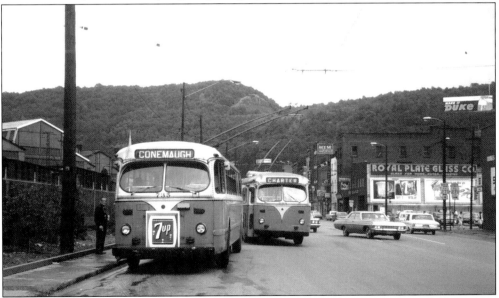

Trackless trolley No. 735 was at a layover point on Washington Street just west of Franklin Street waiting for the departure time for Conemaugh on August 26, 1967. Chartered trackless trolley No. 733 is behind and would follow the regular service vehicle to Conemaugh. Both of these ACF Brill built vehicles had been purchased second hand from the Cincinnati Newport and Covington Street Railway. (Kenneth C. Springirth photograph.)

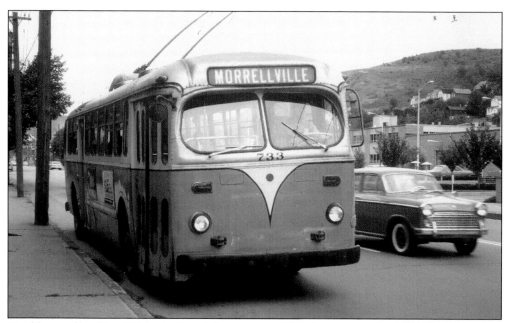

Trackless trolley No. 733 is on Broad Street near Fifth Avenue on the Morrellville line on August 26, 1967. Two parallel wires characterize the overhead system for trackless trolleys, which operate at a low noise level, have fast acceleration, and can steer around obstructions in the roadway. (Kenneth C. Springirth photograph.)

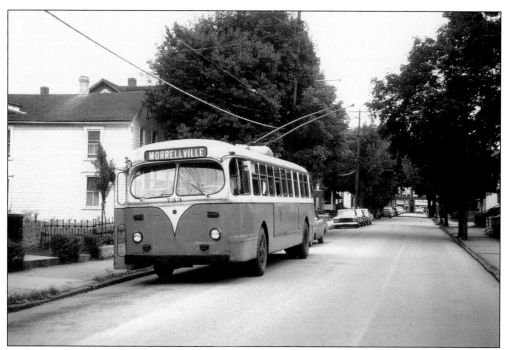

Chandler Avenue, with Fairfield Avenue noted in the background, provide the setting for trackless trolley No. 733 in Morrellville on August 26, 1967. Trackless trolleys only lasted 16 years in Johnstown. (Kenneth C. Springirth photograph.)

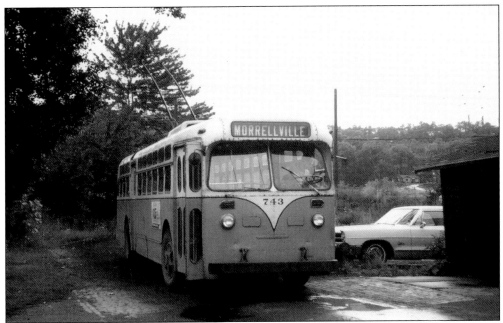

Trackless trolley No. 743, built by Marmon Herrington, is at Roxbury Loop on August 26, 1967, preparing to depart for downtown Johnstown and then to Morrellville. Johnstown Traction Company purchased five Marmon Herrington and six ACF Brill trackless trolleys from the Cincinnati Newport and Covington Street Railway plus 10 ACF Brill trackless trolleys from Delaware Coach Company of Wilmington, Delaware. (Kenneth C. Springirth photograph.)

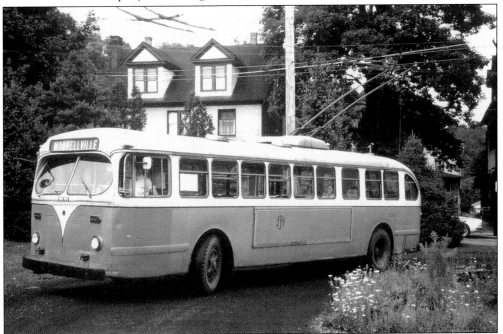

Picturesque Roxbury Loop is the setting for trackless trolley No. 733 on August 26, 1967. The 10 ACF Brill model 40SMT trackless trolleys from Wilmington, Delaware, were originally numbered 662, 664, and sequentially to 672. (Kenneth C. Springirth photograph.)

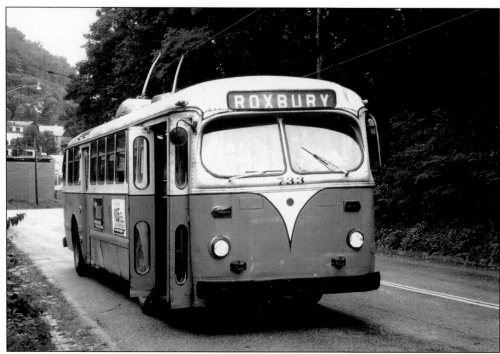

Johnstown Traction Company trackless trolley No. 733 pauses on Roxbury Avenue on the way to Roxbury Loop on August 26, 1967. Johnstown Traction Company had 27 trackless trolleys, which were more than enough to handle the service requirements that required 68 trolley cars during World War II. (Kenneth C. Springirth photograph.)

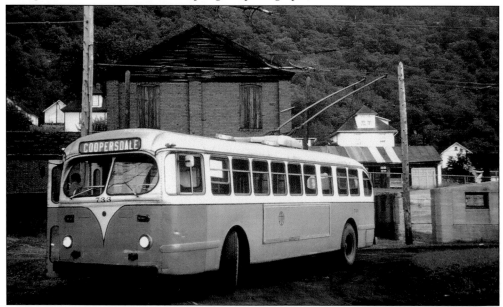

Trackless trolley No. 733, on a special excursion, pauses for a photograph at Coopersdale Loop on August 26, 1967. Philadelphia was the first Pennsylvania city to operate trackless trolleys with their line on Oregon Avenue in 1923. Johnstown was the last small trackless trolley system in the United States. (Kenneth C. Springirth photograph.)

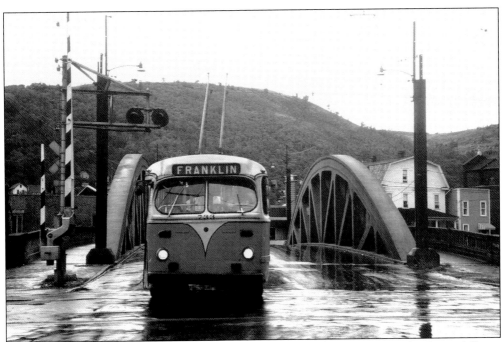

It is a rainy day on August 26, 1967, as trackless trolley No. 733 comes over the Atwood Street bridge from Woodvale. This originally was Cincinnati Newport and Covington Street Railway No. 661, built by ACF Brill as model TC46 in 1952. (Kenneth C. Springirth photograph.)

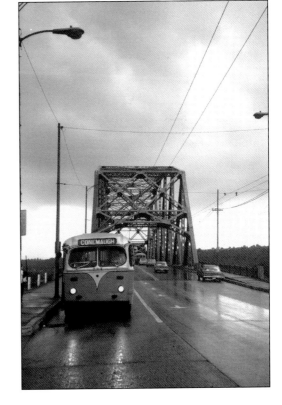

Trackless trolley No. 733 is at the Maple Avenue bridge on the Conemaugh route on August 26, 1967. The Franklin trackless trolley line was extended into Conemaugh on July 1, 1965. Trackless trolleys were introduced in Johnstown on November 19, 1951, and merchants at the Main and Bedford Streets business district warmly welcomed the new vehicles with special sales. (Kenneth C. Springirth photograph.)

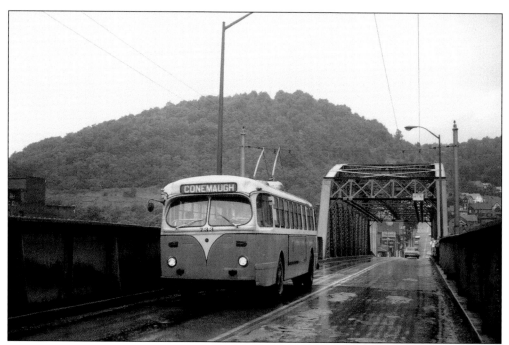

Trackless trolley No. 733 is heading into Franklin Borough from Conemaugh on the Main Street bridge on August 26, 1967. To the left of the trackless trolley on the hillside is the former Southern Cambria Railway right-of-way for the shuttle line to Woodvale. (Kenneth C. Springirth photograph.)

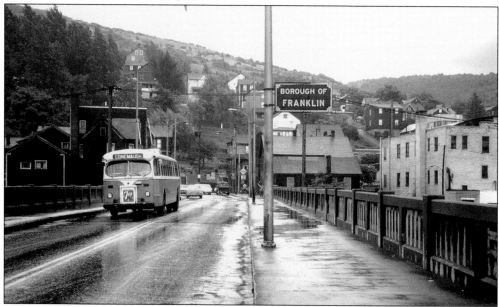

ACF Brill–built trackless trolley No. 733 is heading to Conemaugh on the Main Street bridge on August 26, 1967. Johnstown Traction Company introduced trackless trolleys on November 19, 1951. There were free rides on the Horner Street line on Tuesday, November 20, 1951, from 9:00 a.m. to noon. Merchants advertised trackless trolley treats for everyone. (Kenneth C. Springirth photograph.)

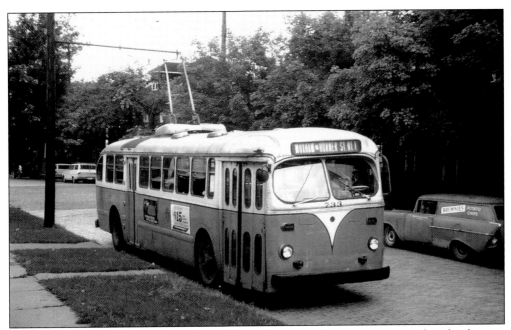

Trackless trolley No. 733 has turned from Village Street onto Linden Avenue, with its brick street and a tree like urban setting, on August 26, 1967. Johnstown and Philadelphia were the only Pennsylvania cities that had trackless trolleys by 1967. (Kenneth C. Springirth photograph.)

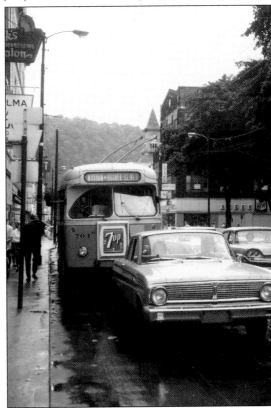

Central Park is in the background at this Main and Franklin Streets location for 48-passenger trackless trolley No. 704 on August 26, 1967. This was one of six vehicles purchased new from St. Louis Car Company for the Horner Street line in 1951 at a total cost of $300,000. (Kenneth C. Springirth photograph.)

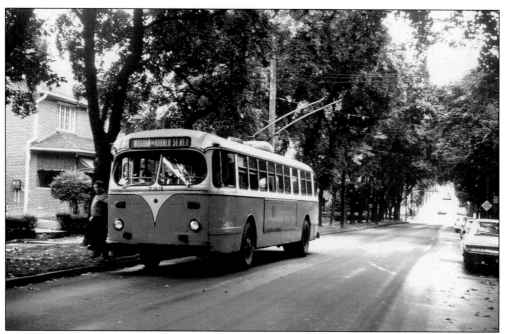

Trackless trolley No. 733 is on Grove Avenue near the top to the hill approaching Ash Street on August 26, 1967. On the first day of trackless trolley operation on November 19, 1951, Foster's Corners at Main and Bedford Streets advertised, "So let's go, ladies get on that trackless, get off at Fosters!" (Kenneth C. Springirth photograph.)

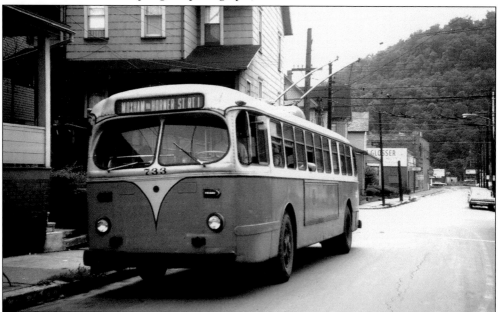

Messinger Street, just off Horner Street, is the setting for trackless trolley No. 733 on August 26, 1967. The November 19, 1951, Fosters advertisement noted, "Here it is, tomorrow, The Johnstown Traction Company inaugurates its trackless trolleys and we offer them our sincere congratulations for bringing to Johnstown (and to our very doors) the modern mode of big city transportation." (Kenneth C. Springirth photograph.)

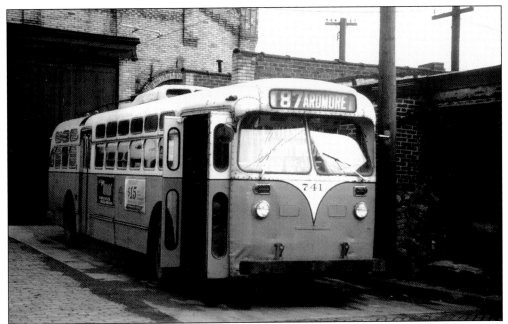

A Pittsburgh Railways roll sign is on Johnstown Traction Company No. 741 at Moxham Car Barn on August 26, 1967. This vehicle was built by Marmon Herrington for the Cincinnati Newport and Covington Street Railway as No. 655 and was the last trackless trolley to operate in Johnstown on November 11, 1967. Seventeen of the trackless trolleys were sold to Mexico City in Mexico. (Kenneth C. Springirth photograph.)

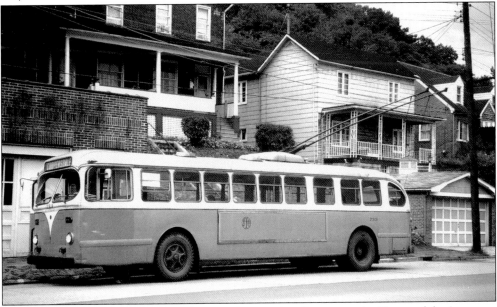

Trackless trolley No. 733 is on Cooper Avenue heading towards Coopersdale Loop on August 26, 1967. After Johnstown Traction Company ended trackless trolley operation on November 11, 1967, vehicle No. 713, which had been purchased second hand from Delaware Coach Company, was acquired by Seashore Trolley Museum in 1968. Another vehicle, No. 623, was acquired by Railways to Yesterday Museum. (Kenneth C. Springirth photograph.)

Retired Cambria County reference librarian Peter Perret on March 30, 2006, at 5:10 p.m. examines a section of girder rail under the worn pavement on Spruce Street at Horner Street in Johnstown. Horner Street trolleys used this trackage until conversion to trackless trolley operation on November 20, 1951. (Kenneth C. Springirth photograph.)

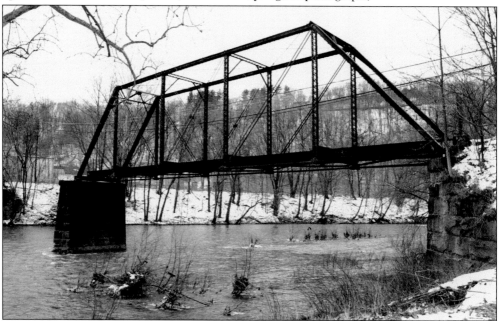

The northern most span of the bridge over Stonycreek River that was used by Ferndale trolleys until November 1959, as viewed on February 7, 2006, is still standing. This bridge can be viewed from the abandoned Johnstown and Stonycreek Railroad right-of-way that is now a park trail on the northern side of Stonycreek River. (Kenneth C. Springirth photograph.)

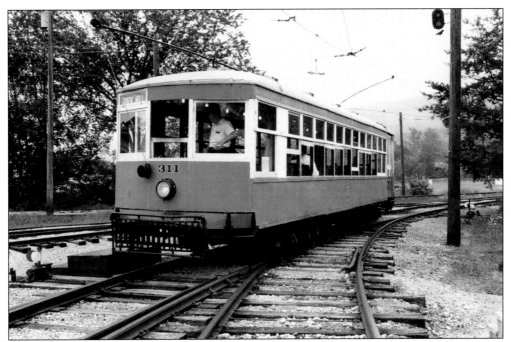

The Rockhill Trolley Museum at Rockhill Furnace, Pennsylvania, operates a three mile museum trolley line over the former Shade Gap Branch of the East Broad Top Railroad. Operation began with Johnstown Traction Company double truck Birney safety car No. 311, obtained after system closure and photographed in its restored condition on June 22, 1996. (Kenneth C. Springirth photograph.)

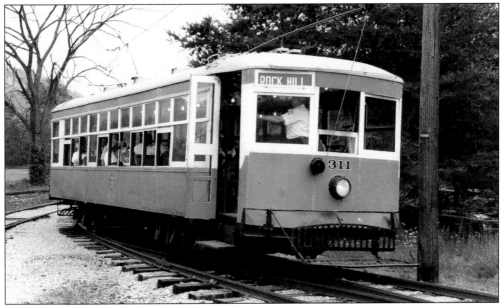

Car No. 311 was a Birney safety car, which had safety equipment that brought the car to a halt if the motorman became disabled. Built by Wason Manufacturing Company for Bangor, Maine, in 1941, it was sold to Johnstown Traction Company and used until June 11, 1960. It was photographed at Rockhill Trolley Museum on June 22, 1996. (Kenneth C. Springirth photograph.)

Repainted in Johnstown Traction Company colors, former Toronto trolley No. 4615 now operates in Kenosha, Wisconsin, as photographed on July 6, 2001. Virginia Springirth wrote the poem "A Special Trip." Let's visit the city, come with me./There are many things to see./Cars and trucks jam the streets near and afar and there's no room for the trolley car./People are scurrying to and fro./There are many places to go./We've seen the city, lets travel on and see what we shall come upon./There comes a train so we must wait./Being delayed is what we really hate./Alas another city we behold./There's something special here I'm told./We see tall buildings they're common you know/and there's stores and restaurants wherever we go./Hush I think I heard a clang/and then there was a bell that rang./What's this? Tracks in the middle of the street?/But then there came something that couldn't be beat./It truly was our heart's delight/to have a trolley car in sight! (Kenneth C. Springirth photograph.)

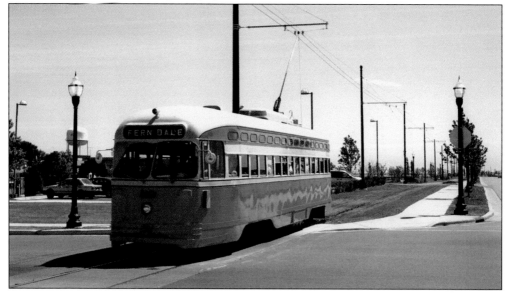

Four

JOHNSTOWN INCLINE

The failure of an earthen dam about 14 miles east of Johnstown resulted in a wall of water roaring into the city on May 31, 1889, killing 2,209 people. The Cambria Iron Company (which later became Bethlehem Steel) began construction of the incline in 1890 so that residents could be lifted safely above any future floodwaters. Construction of the Johnstown Incline, designed by Samuel Diescher of Pittsburgh, began in 1890, and it was opened June 1, 1891. It is a balanced inclined plane having a double track with two cars permanently attached to steel cables, counterbalancing each other while in operation. As one car rises, the other car is lowered. This incline is advertised as the world's steepest incline that carries vehicles. At the top lies the borough of Westmont, which was established after the flood. Most of the steel mill executives and many of the workers moved to Westmont, and the incline was used to reach downtown Johnstown. Bethlehem Steel sold the incline to the Borough of Westmont for $1 on May 1, 1935. During the March 17, 1936, flood, when melting snow and steady rain caused severe flooding, the incline carried 4,000 people to safety. Westmont closed the incline Wednesday night, January 31, 1962, because a modernization program underway at the Bethlehem Steel Johnstown Plant made it necessary to convert to a different cycle power, which would cost the Borough of Westmont $51,000. As ridership declined, it became a financial burden. It was leased to the Cambria County Tourist Council and reopened July 4, 1962. During the July 20, 1977, flood, the incline proved its worth again by getting supplies and relief workers into Johnstown. The Cambria County Transit Authority purchased the incline for $1 on April 12, 1982. On Friday morning, January 7, 1983, the incline was closed. A $4.2 million rebuilding of the incline was completed, and the incline was rededicated on September 6, 1984. On September 4, 2001, the incline was closed to complete repairs on the bridge deck at the bottom of the hillside and reopened December 14, 2001.

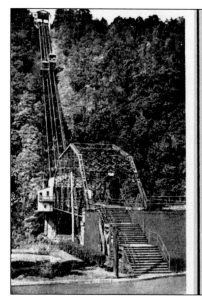
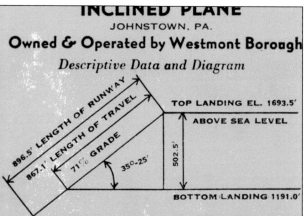

INCLINED PLANE
JOHNSTOWN, PA.
Owned & Operated by Westmont Borough
Descriptive Data and Diagram

Built in 1891; Height 502.5'; 1693.5' Above Sea Level; Length of Runway 896.5'; Angle of Runway 35°25'; Grade Approx. 71%; No. of Steps 900; Size of Car 15'6" x 33'11", 15 Tons Capacity; Size of Rope 2" Diam. 1130' Long, 1 Pulling, 1 Safety; Each Rope Tested to 335,000 Pounds (167.5 Tons); Motor 300 Horsepower; Drum 16'0" Diameter; Weight of Cars 42 Tons Each.

The Johnstown Incline uses two cars that counterbalance each other and always move in opposite directions. The cars leave the upper and lower stations simultaneously and always pass at the midpoint of the track. At the upper level station, there is a stationary engine that provides enough power to overcome friction and the difference in the weight of the two cars.

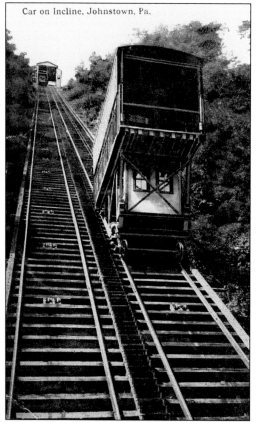

In response to the Johnstown flood of May 31, 1889, the Johnstown Incline was built as an emergency escape route during future floods. In this 1914 postcard the car has just left the lower level, which is downtown Johnstown along the Conemaugh River Valley. This shows the old passenger cabin underneath the main car, which was later removed. The car at the top is in the borough of Westmont on a bluff overlooking the valley.

The approaching bridge for the inclined plane spans Stonycreek River. It was originally constructed of iron and steel with a clear span of 230 feet. There were two tracks of eight foot gauge. Melber of Pittsburgh built the two cars, which each seated about 12 persons. The boiler and engine building were of stone and brick, and its smoke stack with plume of smoke can be seen in this postcard.

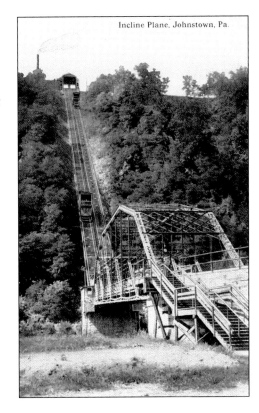

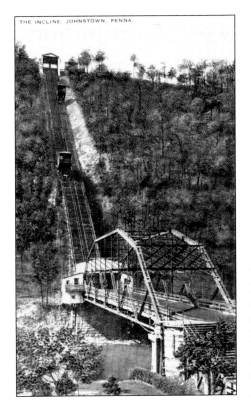

The *Johnstown Tribune* newspaper of March 21, 1891, noted that each car was "attached to a drum and double winding engine at the top of the plane by a two-inch crucible steel wire cable which, being wound and unwound, will raise or lower the cars on the plane." Sparks and Evans did the excavating and masonry. Phoenix Bridge Company furnished the bridge and metal work. Altoona Manufacturing Company built the engine.

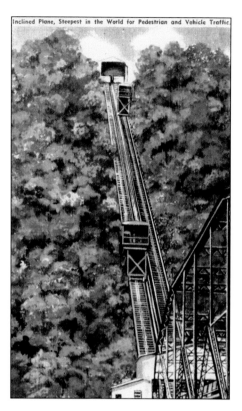

The *Johnstown Tribune* newspaper of January 6, 1912, reported, "Operation of the cars on the Inclined Plane by electricity was tried between 2 and 5 o'clock yesterday morning for the first time." The article continued, "While the new power was being used, the engines were disconnected." This postcard was been made after the smoke stack was removed.

The October 30, 1936, article in the *Johnstown Tribune* newspaper noted, "Works Project Administration forces will start next week to repair the approach and bridge at the foot of the Inclined Plane, clearing the way for resumption of vehicular service on the incline." The Federal Government provided $17,810 and Westmont provided $2,890 for new concrete retaining walls and new bridge flooring. Vehicular traffic was discontinued before Westmont took over the incline.

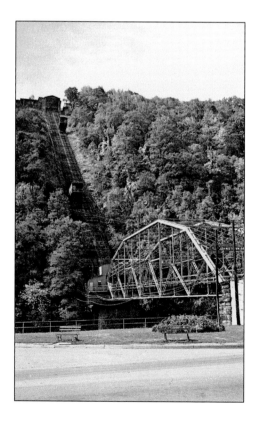

Incline service was suspended on Saturday, June 3, 1961, as about 100 volunteers cleaned, painted, installed new lighting, built a new sign board, and erected a new lookout post overhanging the rim of the hill. Many of the workers put in dawn to dusk shifts for three consecutive Saturdays donating their time to beautify the incline. Materials were donated by 38 companies, and local contractors loaned equipment. (Harold Jenkins photograph.)

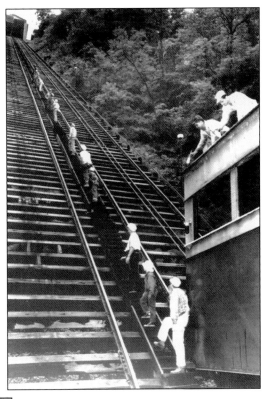

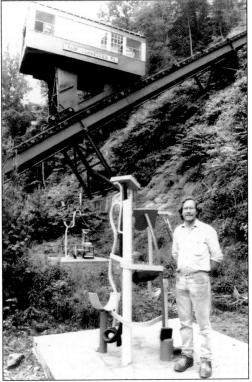

James Wolf, shown with one of his artworks, created a series of sculptures along the switchback trail that winds up Yoder Hill to Westmont near the Johnstown Incline. Wolf spent almost a year during 1989 working in the Bethlehem Steel mill using actual production remnants to create the sculptures. (Harold Jenkins photograph.)

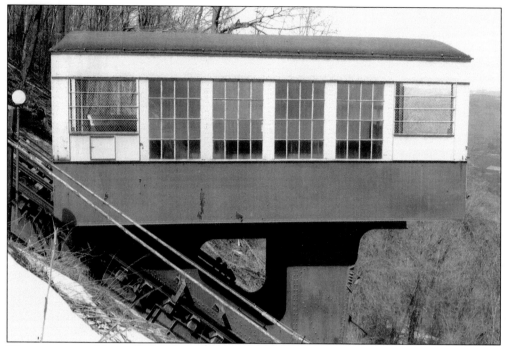

This was a view of the incline car before the rebuilding, which began in 1983. On October 22, 1978, a total of 12 volunteers, including laid-off steelworkers, five incline employees, and three Westmont borough employees, installed new cables at the incline. (Harold Jenkins photograph.)

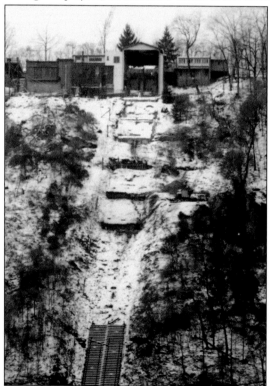

The incline was closed on January 7, 1983, and this winter scene shows the reconstruction. At a cost of $4.2 million the incline's foundation piers, structural steel, and track were replaced. The two incline cars were rebuilt, upper and lower stations refurbished, and mechanical and electrical systems were overhauled. Incline service was restored on September 6, 1984. (Johnstown Area Heritage Association Archives.)

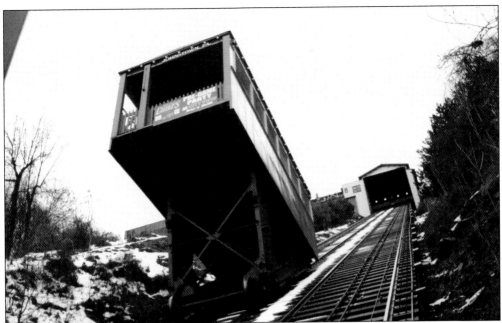

In this January 3, 2006, winter view, incline ridership is light. Incline ridership reached its peak in 1919 when it handled 1,356,293 passengers. Ridership for fiscal year 1995–1996 was 142,134. The low point was fiscal year 2000–2001 with 66,654 riders. Ridership for fiscal year July 1, 2004 to June 30, 2005 was 86,069. (Kenneth C. Springirth photograph.)

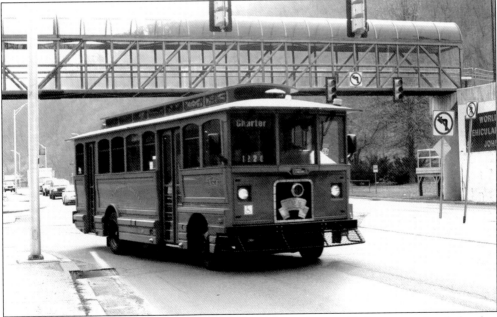

On February 2, 2006, Cambria County Transit Authority's route 18 downtown shuttle bus has just turned from Vine Street onto the Route 56 Expressway in Johnstown, providing a convenient stop for incline plane passengers. Directly behind the bus is the pedestrian crosswalk bridge, which was built at a cost of $625,000 and opened on September 8, 1994, to access the inclined plane. (Kenneth C. Springirth photograph.)

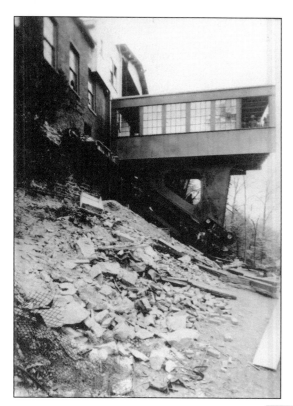

Each of the Johnstown Incline cars was originally a double deck structure with space for pedestrians below and wagons and horses above. This 1921 side view of the car shows the reconstruction, which eliminated the double deck. (Johnstown Area Heritage Association Archives.)

At the lower level there is easy access to the hill side trail that goes under the incline. On May 13, 2006, incline riders, from left to right, Eric Turnbull holding Faith Turnbull, Grace Turnbull, Kathleen Ruggio holding Angelo Ruggio, Timothy Springirth, and Virginia Springirth, pause to explore the picturesque incline area. (Kenneth C. Springirth photograph.)

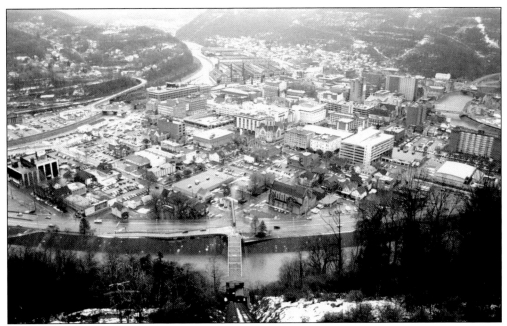

The view from the upper incline plane station is spectacular in this January 3, 2006, scene. Towards the bottom of the picture is Stonycreek River. A portion of the Conemaugh River is shown in the upper left. The lower incline station is on the west bank of the Stonycreek River, which flows into the Conemaugh River. (Kenneth C. Springirth photograph.)

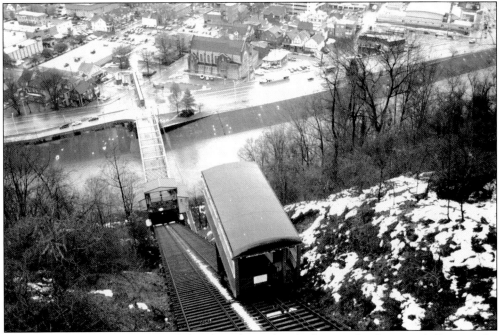

It was cold on January 3, 2006, while riding the incline looking at the Stonycreek River in the center of the picture and a portion of downtown Johnstown. To reflect the historical nature of the incline, on Monday, May 1, 2006, all incline operators and conductors began wearing new vintage-style uniforms. (Kenneth C. Springirth photograph.)

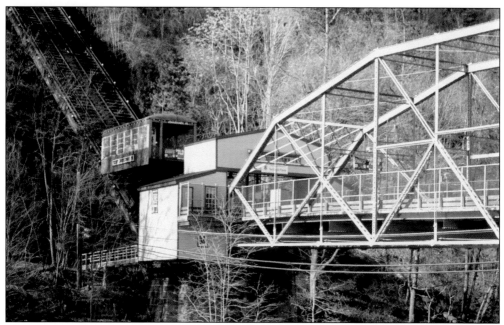

A view of the Johnstown Incline lower station with a portion of the bridge over Stonycreek River is basking in the winter sun of January 12, 2006. Johnstown Traction Company operated the Westmont bus on the incline beginning February 22, 1938. In July 1953, buses abandoned the incline and began using the new state Highway 271. (Kenneth C. Springirth photograph.)

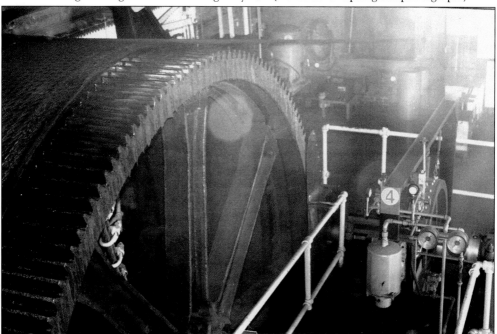

In this January 12, 2006, upper level view, the incline pulling cables are wound over a 16 foot diameter cast steel drum, which winds and unwinds the cables simultaneously. A 400 horsepower electric motor drives the cast steel drum. As one car goes up the incline, the other car comes down. The weight of the two cars counterbalance each other. (Kenneth C. Springirth photograph.)

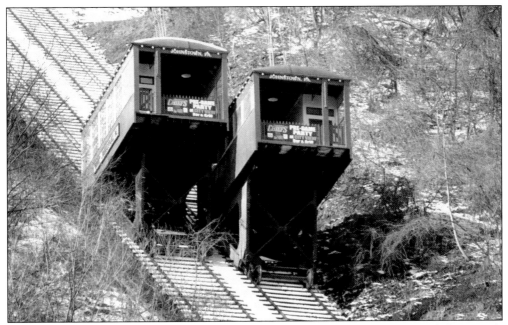

The Johnstown Incline is also known as a funicular that uses two cars that counterbalance each other and always move in opposite directions. They leave the upper and lower stations at the same time and provide a level ride for pedestrians and vehicles. As shown is this February 14, 2006, view, the cars pass at the midpoint of the track. (Kenneth C. Springirth photograph.)

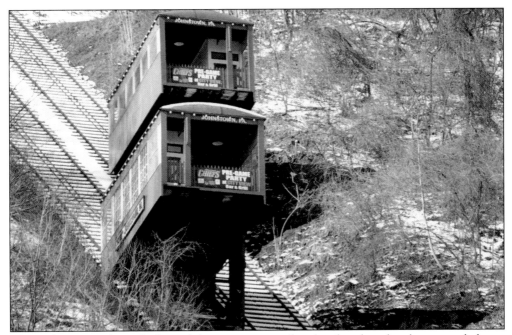

The incline cars almost look as if they are on top of each other, but they have traveled past the midpoint. The car at the top of the picture is heading upward while the lower car is heading downward in this winter scene with a light dusting of snow on February 14, 2006. (Kenneth C. Springirth photograph.)

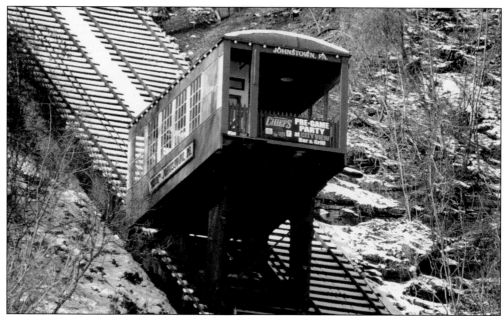

As road improvements were made and more people drove automobiles, use of the incline declined. The incline was shut down January 31, 1962, because of financial issues and was leased to the Cambria County Tourist, which reopened it July 4, 1962. It was shut down for rebuilding January 7, 1983, and was reopened September 6, 1984. Monday, September 25, 2000, the incline was closed while the Pennsylvania Department of Transportation completed a $2.3 million renovation of the bridge that spans Stonycreek River and rebuilt the access road to the bridge and incline. The Pennsylvania Department of Transportation completed enough of the bridge to allow reopening of the incline for round trips from the top on Sunday, April 8, 2001. On September 4, 2001, it was closed to complete repairs on the bridge deck at the bottom of the hillside and reopened December 14, 2001. (Kenneth C. Springirth photographs.)

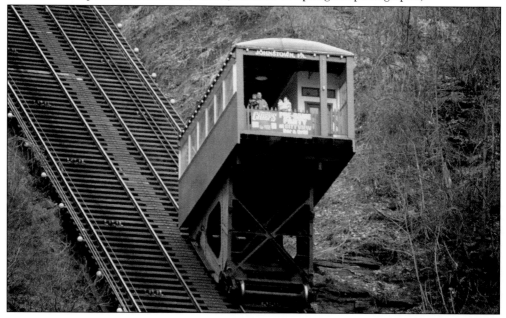

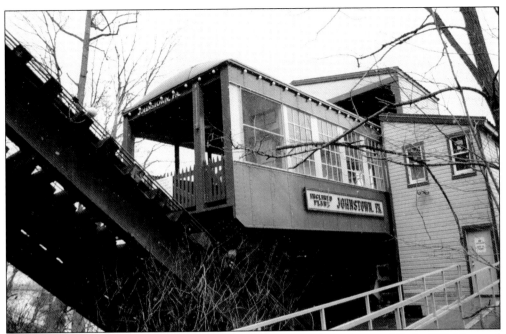

The James Wolf Sculpture Trail provides a nice way to view the incline and Yoder Hill. The trail can be accessed through the special doorway shown in the above view at the lower level taken March 14, 2006. From the front side one would go through the special doorway at the lower level conductor's booth and down the stairs and out the above door. The trail traverses the front slope of Yoder Hill and brings one to the top of the incline, just south of the Visitor's Center on Edgehill Drive. At the top of the incline the trail is accessed on Edgehill Drive just south of the incline buildings. In the below view, taken from the lower level trail on April 13, 2006, the incline car has just left the lower station. (Kenneth C. Springirth photographs.)

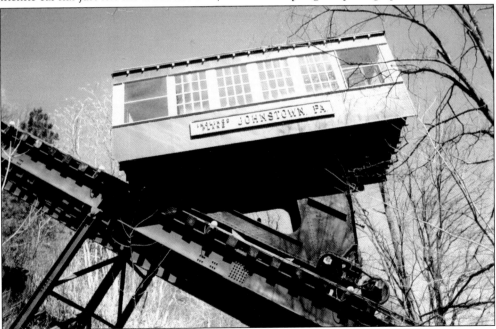

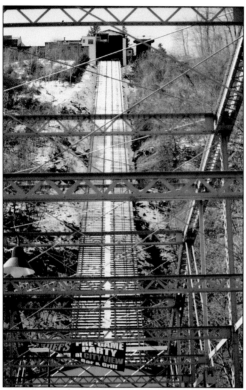

In this view from the lower level taken February 14, 2006, the incline has 720 ties that are 12 inches by 12 inches by 14 feet long. The Wolmanized (treated) ties are No. 1 dense Southern Yellow Pine. The total length of the incline rails is 3,586 feet, rail weight is 85 pounds per yard, and average rail length is 37.5 feet. The incline has 114 high-pressure sodium lights. (Kenneth C. Springirth photograph.)

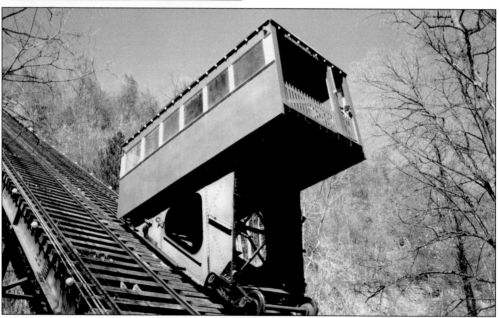

In this April 13, 2006, view, each incline car, weighing 22 tons, has arch bar trucks, and the undercarriage weighs 16 tons. The incline has 900,000 pounds of structural steel. There are 16 foundations (723 cubic yards of concrete) with an average size of five and a half feet wide, eight feet deep, and 30 feet long. Cables are two inch power steel wire rope with a breaking strength of 396,000 pounds. (Kenneth C. Springirth photograph.)

Five

CAMBRIA COUNTY TRANSIT AUTHORITY

With a severe decline in riding, Johnstown Traction Company wanted to get out of providing transit service. On December 1, 1976, Cambria County Transit Authority, formed by the county commissioners, leased Johnstown Traction Company assets and officially began providing transit service in the Johnstown area. Ownership of the Johnstown Incline was transferred from the Borough of Westmont to the Cambria County Transit Authority for $1 on April 12, 1982. A new downtown transit center was built at 551 Main Street, which features trolley cars in the mosaic tile. Sunday bus service, which had been discontinued by Johnstown Traction Company in 1962, was restored during September 2000. A renaissance trolley shuttle, using buses designed to look like trolleys, began operation in the downtown area in 2001. Numbered 124 and 125, the replica trolley-style buses were built by Chance Coach Company of Wichita, Kansas, and are currently used on Route 18 downtown shuttle, which provides service to the incline and Amtrak Train Station. In July 2004, an antique Johnstown Traction Company 1948 General Motors bus No. 402 was transferred to the Museum of Bus Transportation in Hershey, Pennsylvania. Currently there are 15 urban bus routes that radiate from the transit center. The rural division operates six fixed routes in northern Cambria County serving Patton, Northern Cambria, St. Benedict, Hastings, Carrolltown, Ebensburg, and Cresson, plus provides bus service between Johnstown and Ebensburg. For the year ending June 30, 2005, the Cambria County Transit Authority urban division with 28 buses carried 1,169,796 passengers and its rural division with 23 vehicles carried 101,588 passengers. From the transit center, Westmoreland Transit links Johnstown with Pittsburgh via bus route 11 to Latrobe where bus route 9 provides service to Greensburg where transferring to bus route 4 takes one to downtown Pittsburgh. While the trip would take about four hours each way, it provides accessibility to a number of Pennsylvania communities that would otherwise not have public transit service. Cambria County Transit Authority's urban and rural divisions provide extensive coverage in Cambria County and its urban division serves Windber borough in Somerset County.

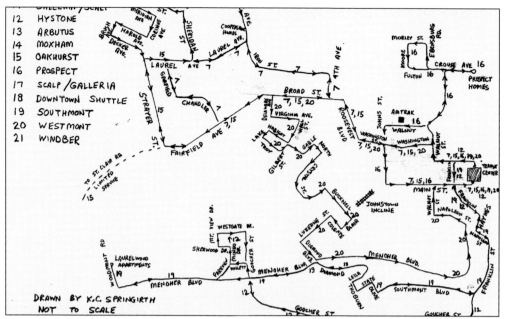

Cambria County Transit Authority operates 15 bus routes in its urban division. The upper map shows bus routes that operate in the western part of the city. The lower map shows bus routes that operate in the eastern part of the city. All urban transit routes come into the transit center at 551 Main Street in downtown Johnstown. The route 18 downtown shuttle map, shown on page 126, provides service to the Johnstown Incline and the Amtrak train station. Bus route 6 Conemaugh, travels through one of the former steel mill areas of the city. Bus route 20 serves the picturesque community of Westmont. Historic Cambria City area just west of downtown Johnstown can be reached by bus routes 7 Coopersdale and route 15 Oakhurst.

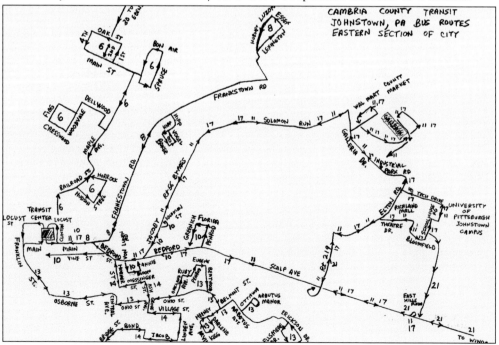

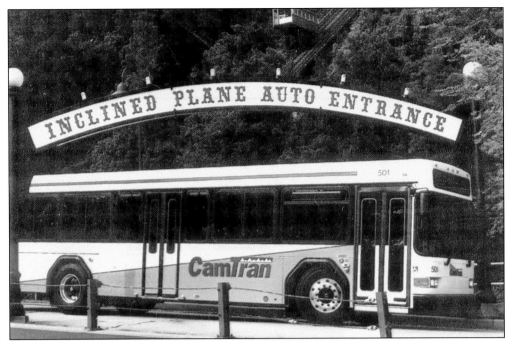

Cambria County Transit Authority bus No. 501 poses at the Johnstown Incline. The route 18 downtown shuttle, as noted by the August 3, 2003, schedule, operates every 25 minutes weekdays with the first trip stopping at the incline at 9:12 a.m. and the last trip stopping at the incline at 2:55 p.m. Five trips stop at the incline on Saturday and three trips on Sunday. (Cambria County Transit Authority photograph.)

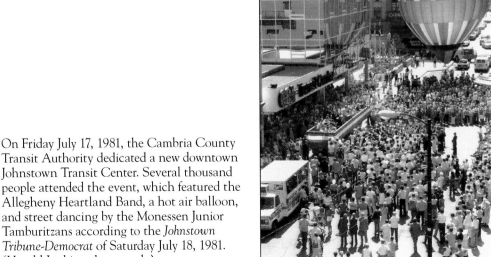

On Friday July 17, 1981, the Cambria County Transit Authority dedicated a new downtown Johnstown Transit Center. Several thousand people attended the event, which featured the Allegheny Heartland Band, a hot air balloon, and street dancing by the Monessen Junior Tamburitzans according to the *Johnstown Tribune-Democrat* of Saturday July 18, 1981. (Harold Jenkins photograph.)

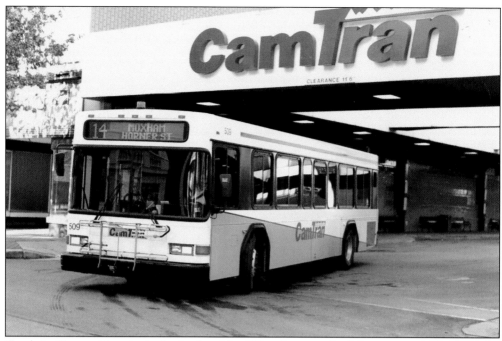

Cambria County Transit Authority bus No. 509 is leaving the Johnstown transit center on Main Street on January 12, 2006. Built by Gillig in 1999, this bus is handling an early afternoon assignment on route 14 to Moxham via Horner Street. A portion of this route follows the old rail line on Horner Street, Messinger Street, Ash Street, Grove Avenue, and Ferndale Avenue. (Kenneth C. Springirth photograph.)

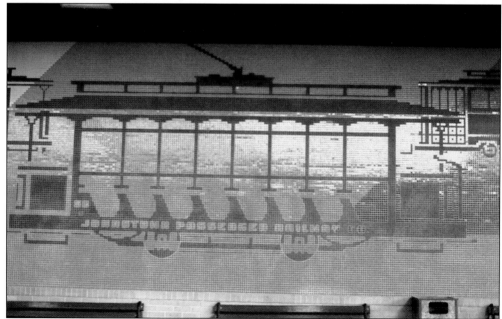

The Cambria County Transit Authority transit center on Main Street in Johnstown was dedicated on Friday July 17, 1981, as part of a $6 million downtown redevelopment project. Trolley cars are pictured in the mosaic tile in the bus waiting area. (Kenneth C. Springirth photograph.)

Cambria County Transit Authority bus No. 517, built by Gillig in 2005, has made a passenger stop on Fairfield Avenue and is about to make the turn onto Strayer Street on January 12, 2006. Bus route 15 loops in Oakhurst while the trolley looped in Morrellville via Chandler Avenue, Strayer Street, and Fairfield Avenue. (Kenneth C. Springirth photograph.)

Built by Gillig in 1999, Cambria County Transit Authority bus No. 508 is westbound on Locust Street just west of Franklin Street in downtown Johnstown on January 12, 2006. Bus routes 7 Coopersdale, 15 Oakhurst, and 20 Westmont/Brownstown serve this portion of Locust Street. Central Park is located on the south side of Locust Street. (Kenneth C. Springirth photograph.)

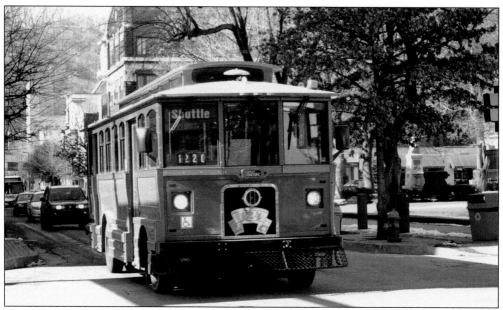

Eastbound on Main Street and ready to cross Franklin Street on February 14, 2006, the route 18 downtown shuttle bus, designed to look like a trolley, was built by Chance Bus Company in the year 2000. This route provides comprehensive coverage in downtown Johnstown linking the Johnstown Incline, Amtrak Train Station, Cambria County Library, flood museum, city hall, and retail establishments. (Kenneth C. Springirth photograph.)

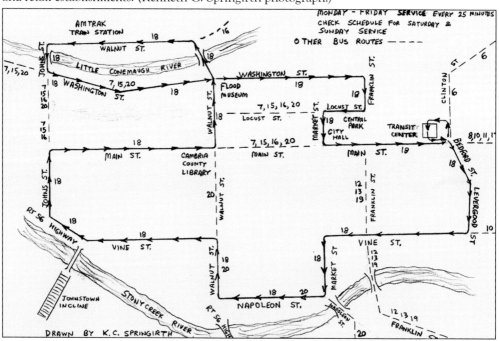

As shown by the above map, the route 18 downtown shuttle makes a wide loop linking the transit center with a variety of points of interest and takes 18 minutes during weekdays and 15 minutes on weekends. The August 3, 2003, schedule shows 15 trips Monday to Friday, 5 trips on Saturday, and 3 trips on Sunday.

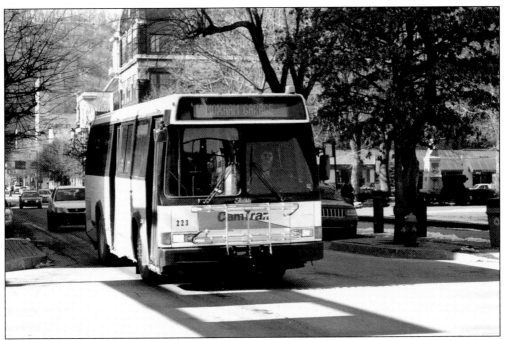

It was a sunny cold winter day, February 14, 2006, as Cambria County Transit Authority bus No. 223 is headed eastbound on Main Street turning onto Franklin Street bound for the Moxham garage. This 30-foot bus seating 29 passengers was built by the Flexible Bus Company in 1993. (Kenneth C. Springirth photograph.)

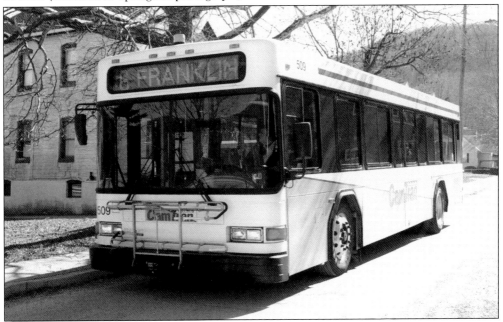

Cambria County Transit Authority bus No. 509 is on Bon Air Street at the Main Street intersection in Franklin borough, with the Franklin Loop on the left side of the bus on March 7, 2006. This 35-foot-long bus was built by Gillig in 1999. In 2006, there are no regularly scheduled trips into the Franklin Loop. (Kenneth C. Springirth photograph.)

Discover Thousands of Local History Books
Featuring Millions of Vintage Images

Arcadia Publishing, the leading local history publisher in the United States, is committed to making history accessible and meaningful through publishing books that celebrate and preserve the heritage of America's people and places.

Find more books like this at
www.arcadiapublishing.com

Search for your hometown history, your old stomping grounds, and even your favorite sports team.

Consistent with our mission to preserve history on a local level, this book was printed in South Carolina on American-made paper and manufactured entirely in the United States. Products carrying the accredited Forest Stewardship Council (FSC) label are printed on 100 percent FSC-certified paper.